Copyright © 2018 by Pattie Schleicher

All rights reserved. No part of this book may be reproduced or used in any manner without written permission of the copyright owner except for the use of quotations or pictures in a book review.

For more information, visit my website:
http://www.pattiesueillustration.com

ISBN: 9781790544554

## Greetings Color Adventurer,

This book is aimed to provide a unique coloring book with hand-drawn illustrations of landscapes, hand-lettering, and adventure-themed topics. The illustrations are at various levels of detail and complexity to keep you excited and engaged for hours. Illustrations are in both a vertical and horizontal format to ensure variation of compositions for the adventurer. Each coloring page is on one sheet (printed single sided) to ensure that bleeding does not sacrafice an image printed on the reverse page. Perfect with your choice of coloring tools such as: Crayon, Gel Pens, Markers, Colored Pencils.

Helpful Hint: If using alchohol based markers, put a scrap paper between the back of your coloring page and the following illustration to ensure that you can render to your hearts content without worrying about bleeding through the paper.

## May your coloring adventure begin!

A dedicated space to try your materials.
Try out your coloring techniques.

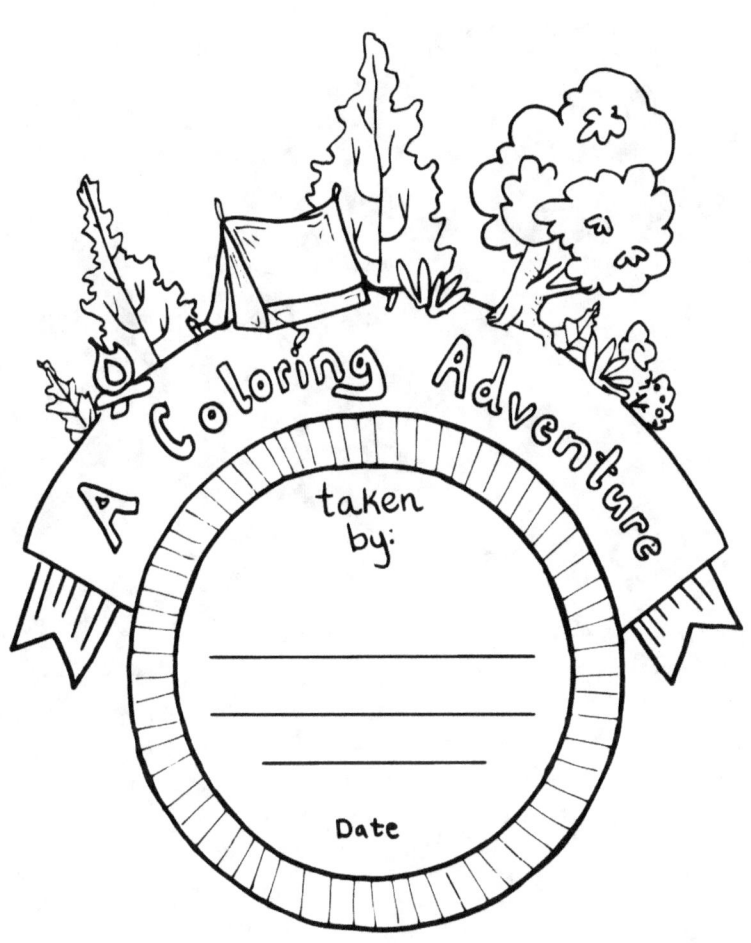

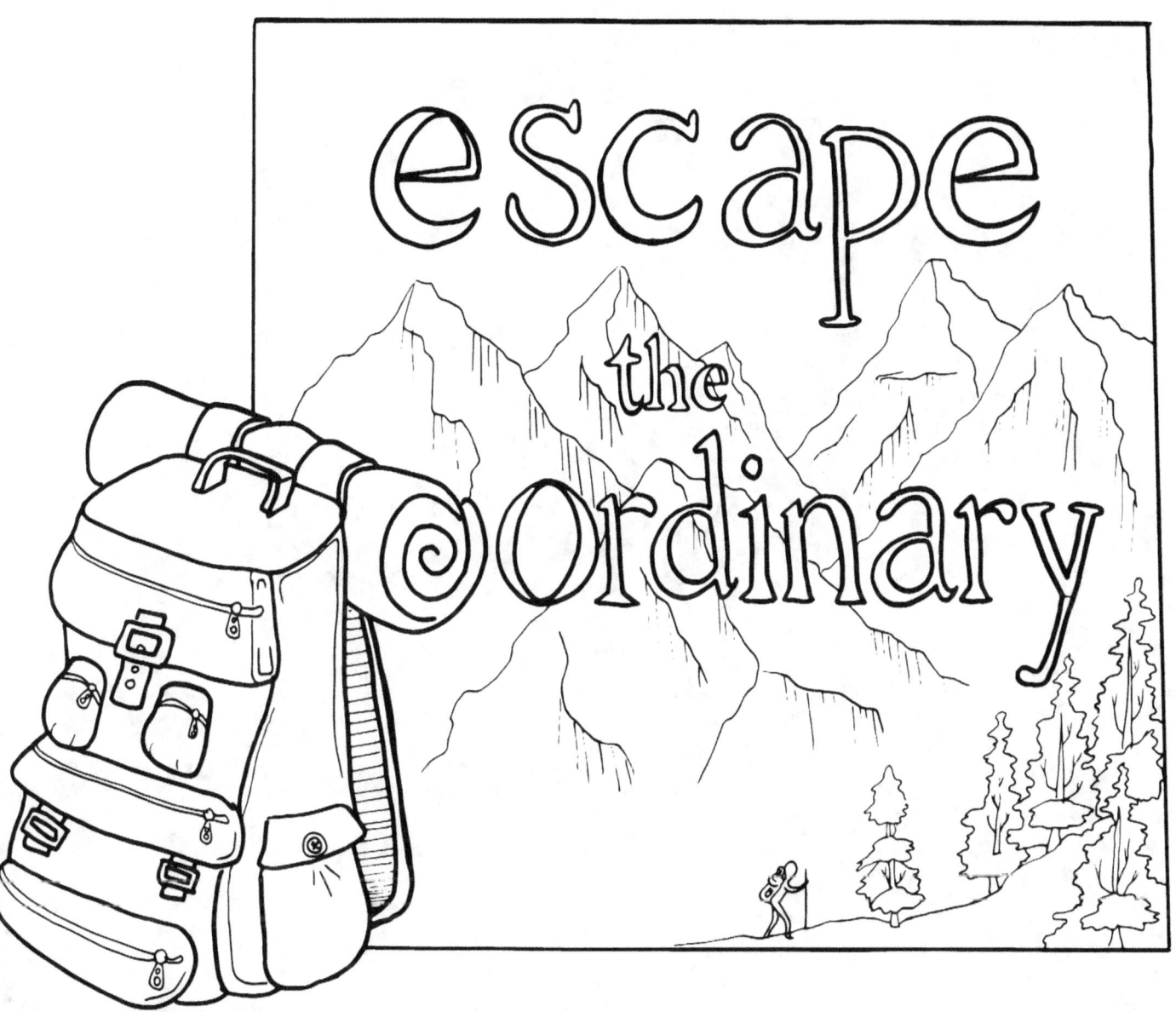

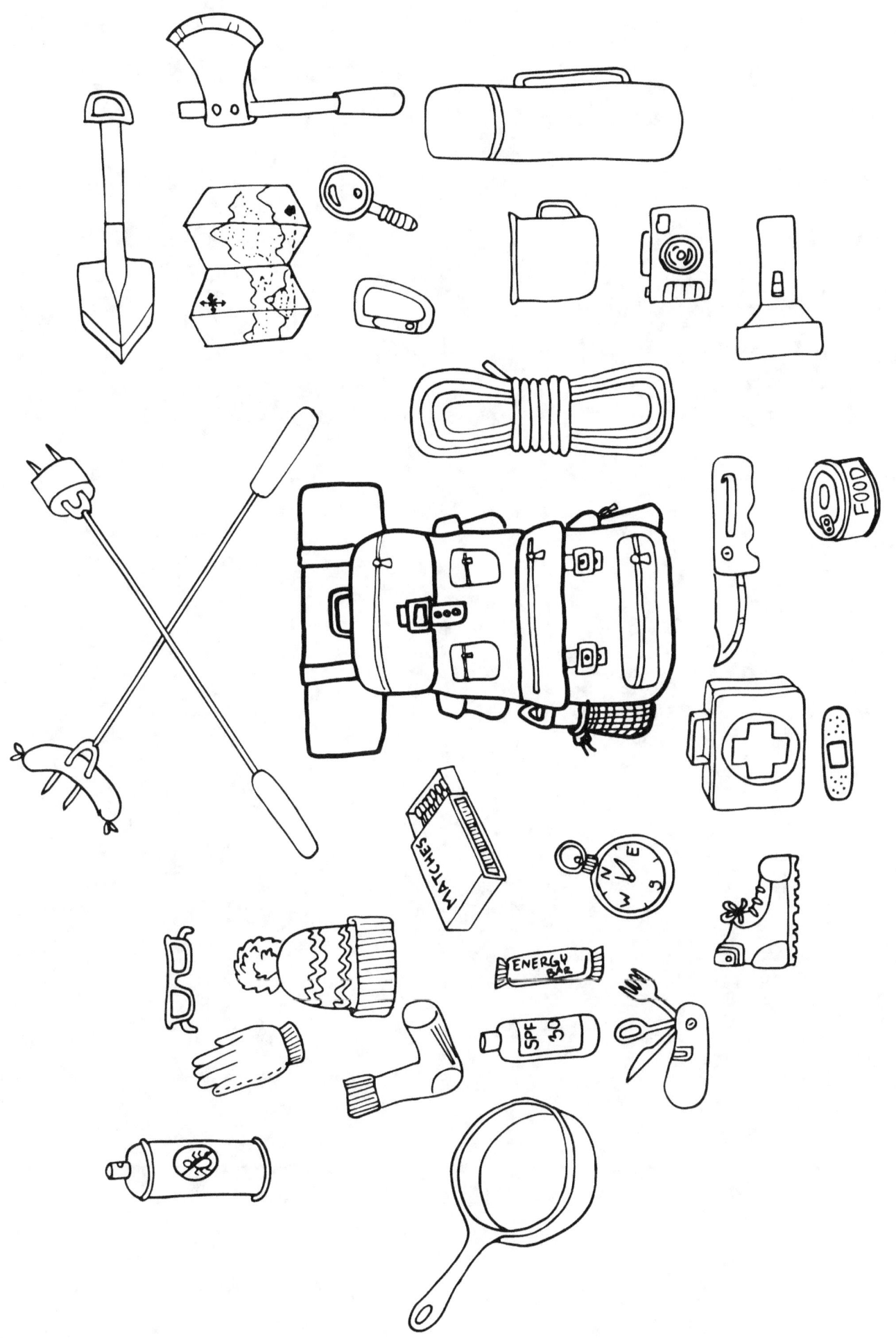

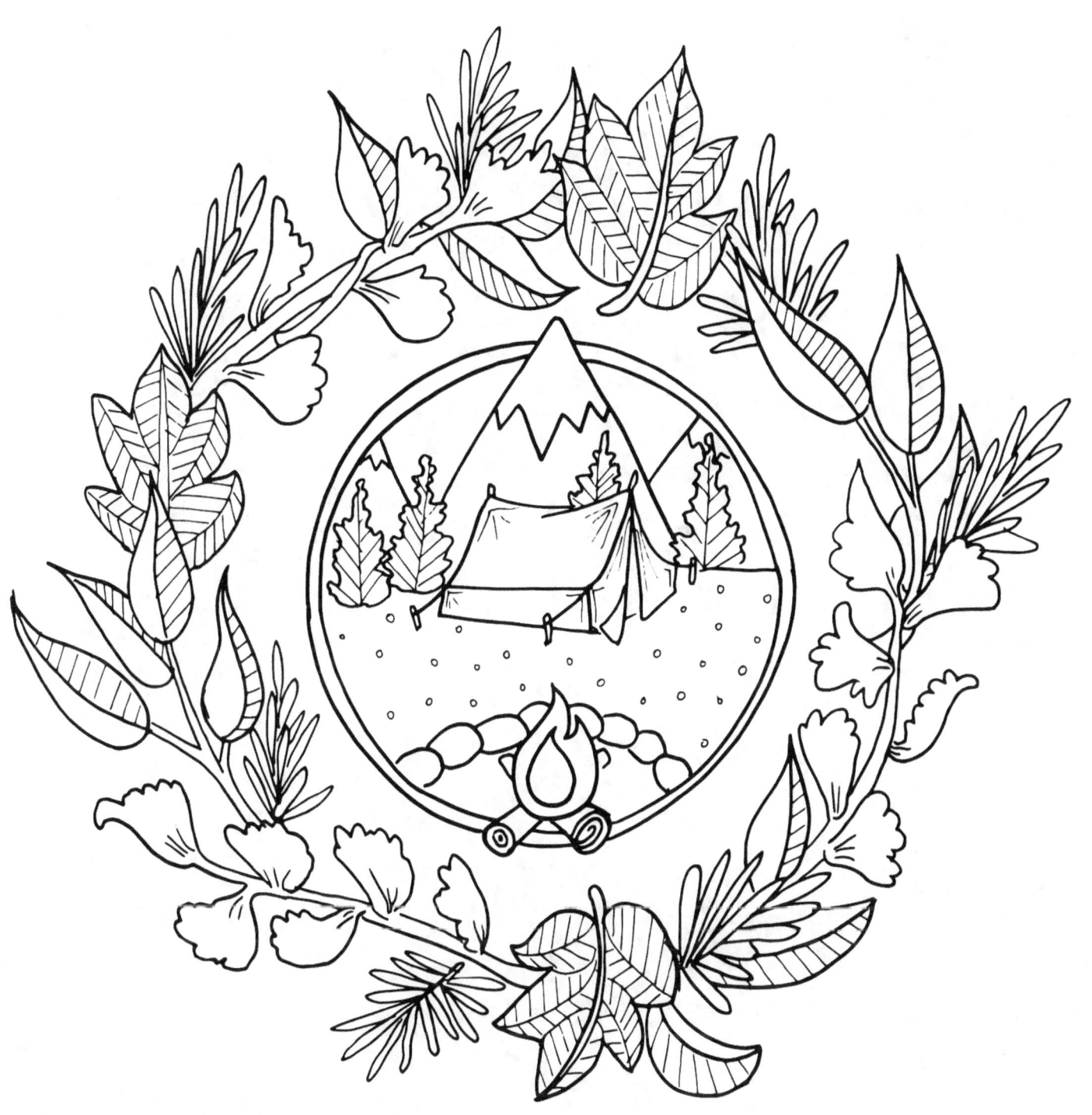

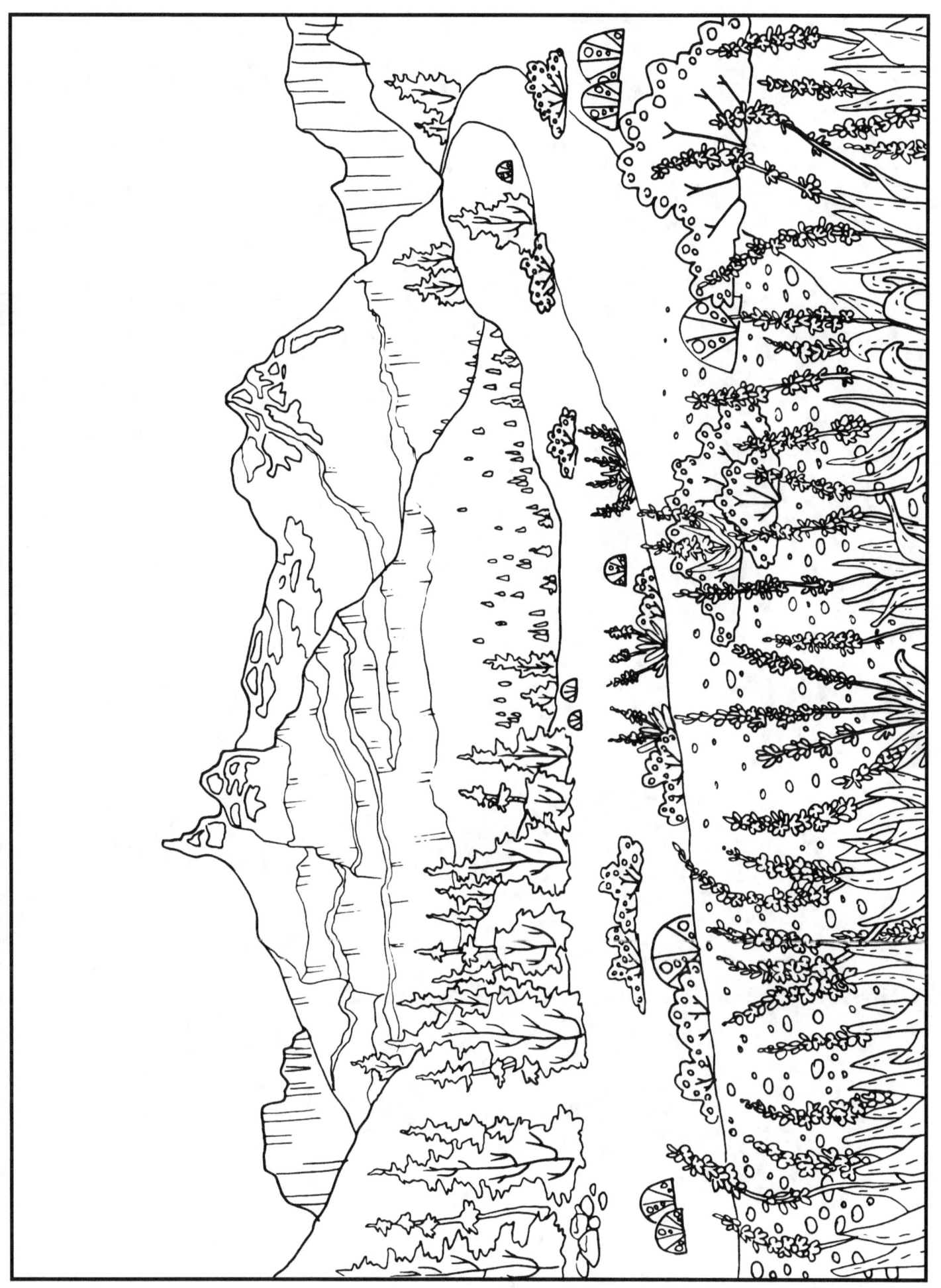

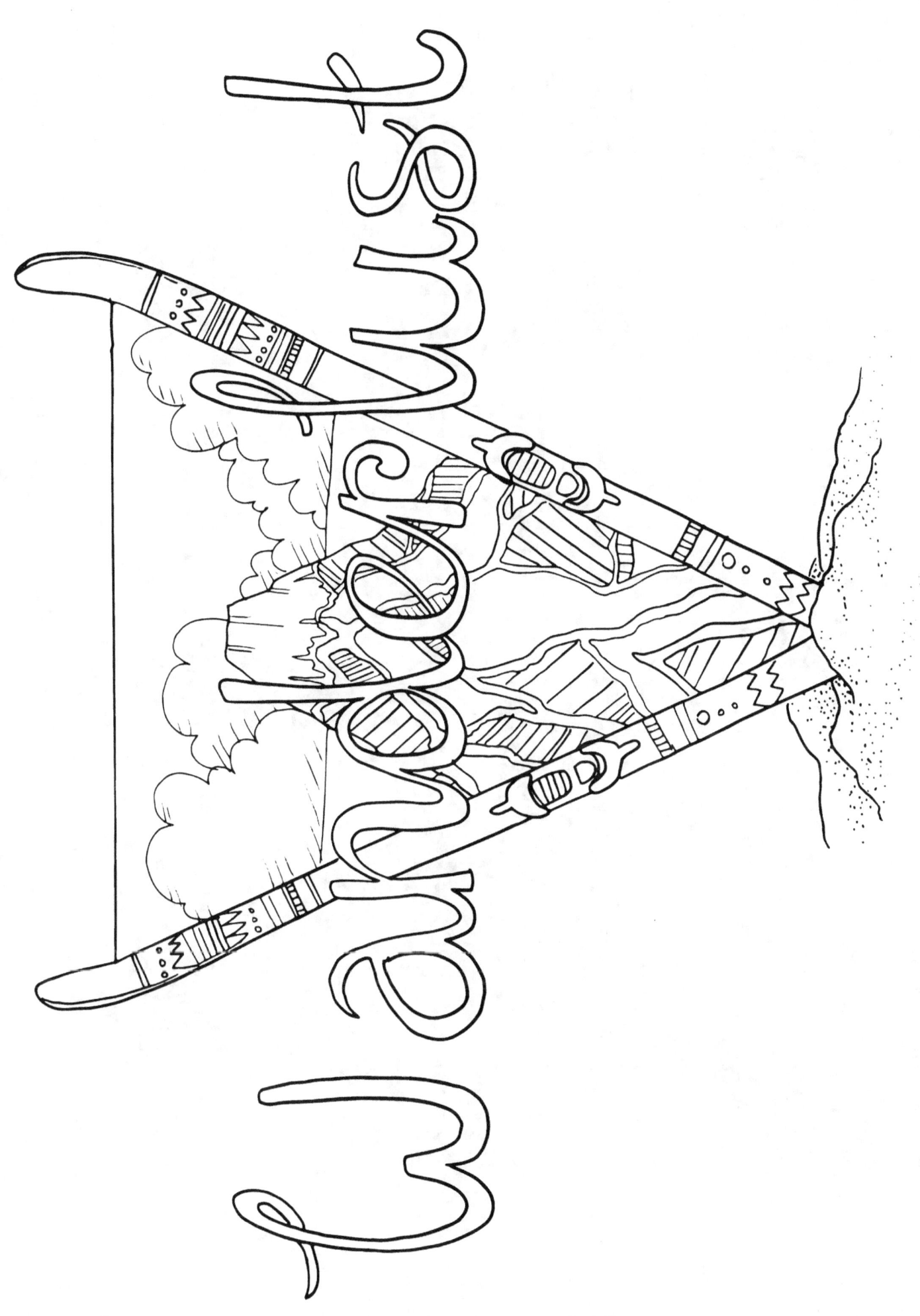

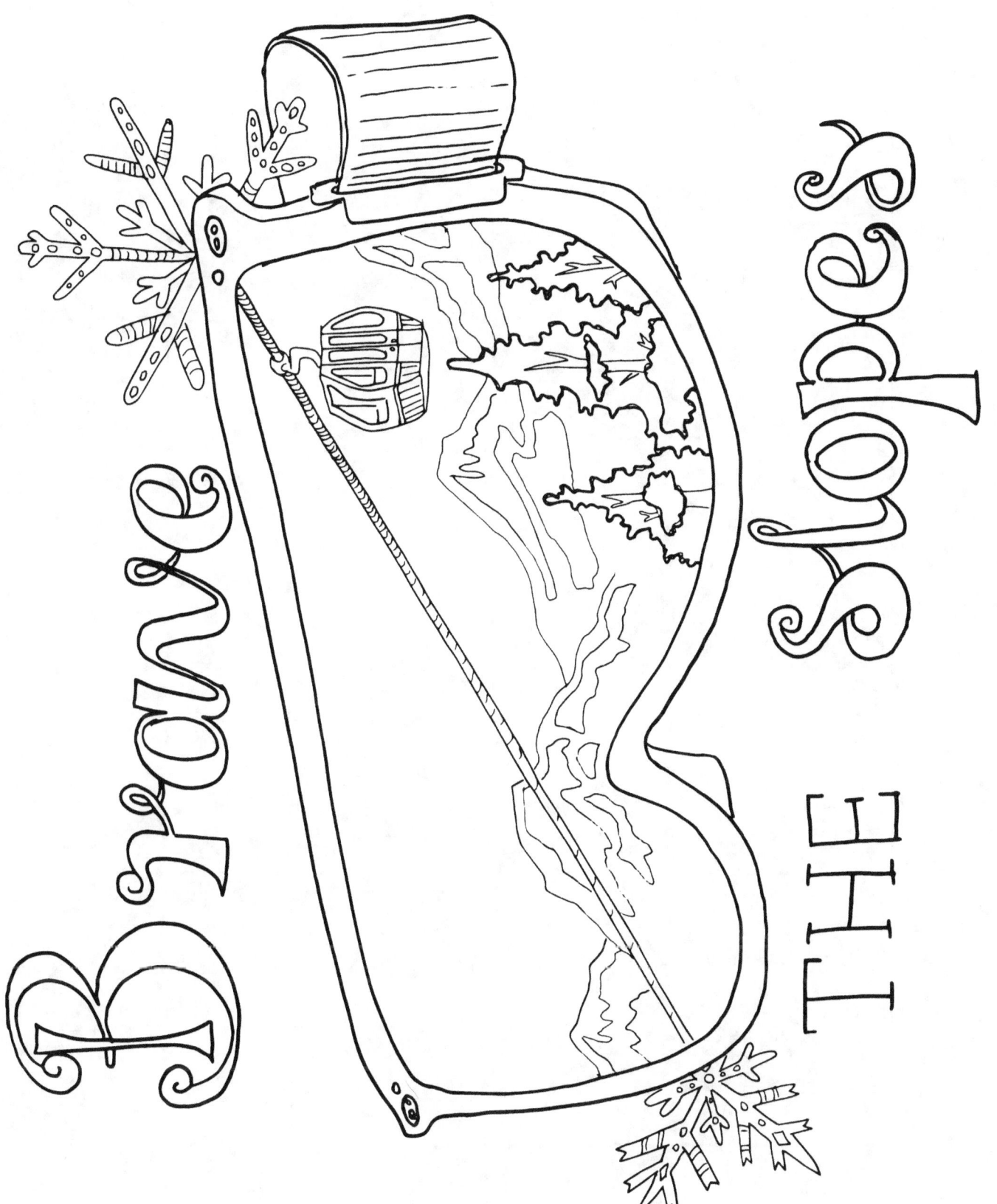

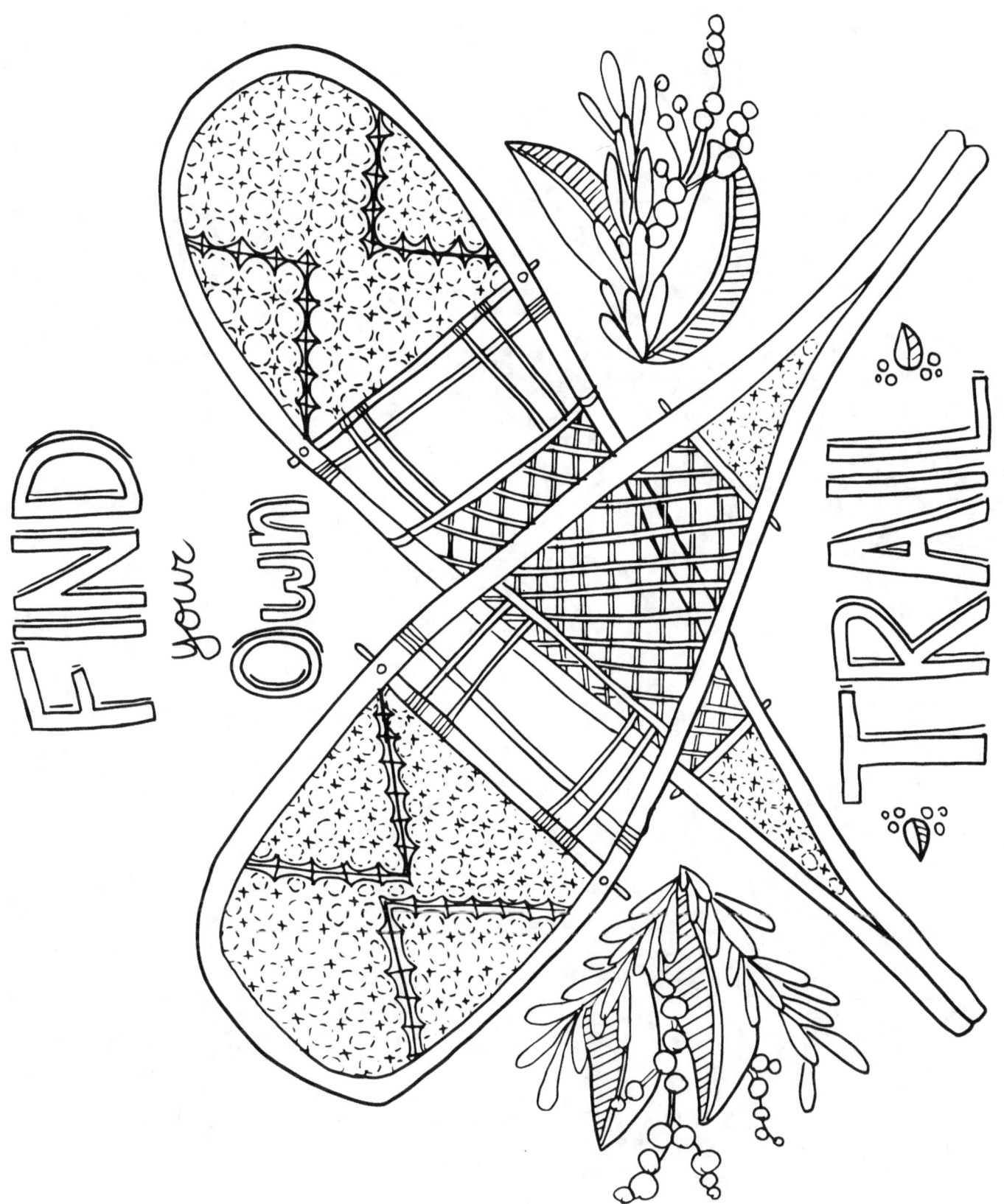

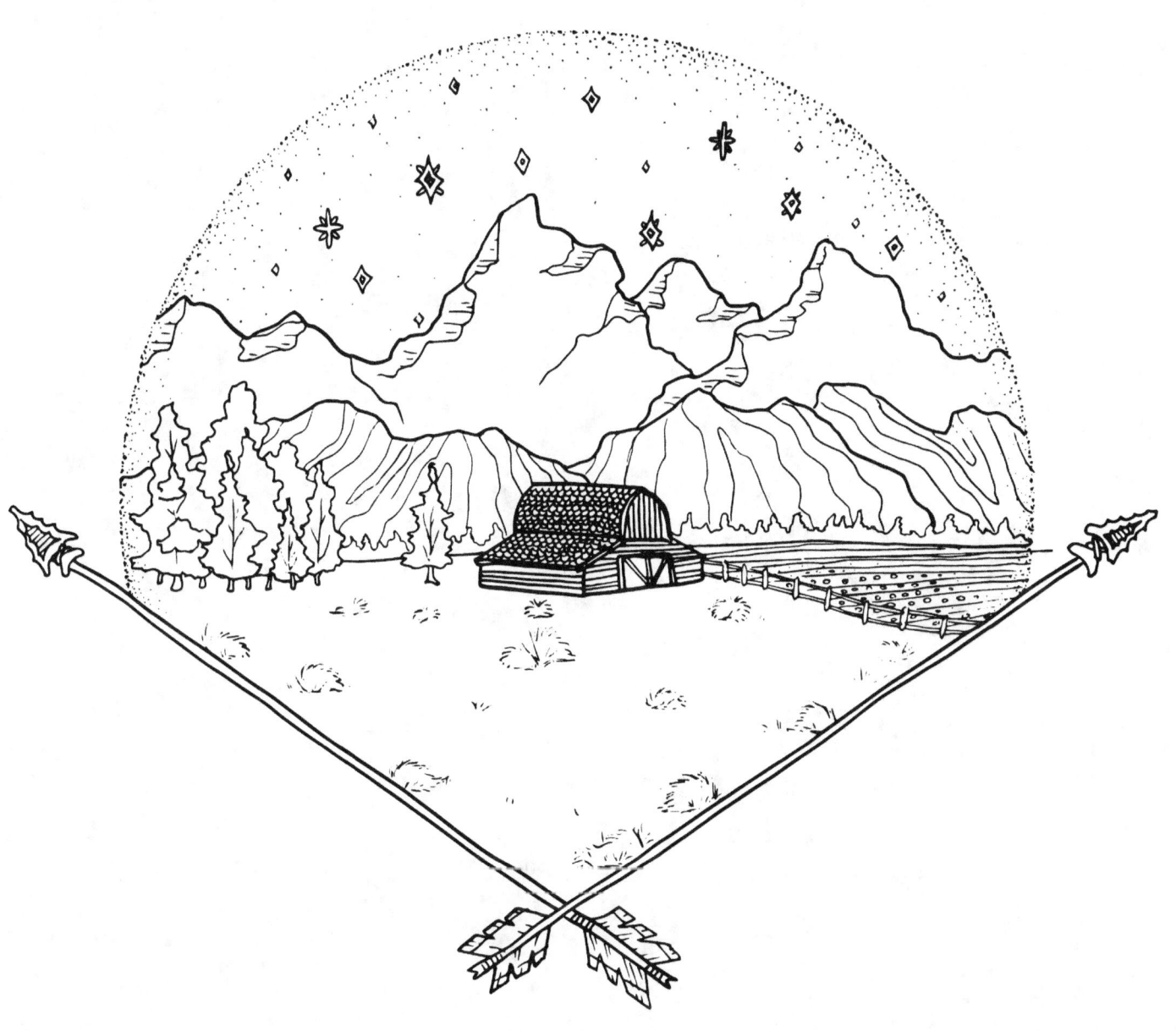

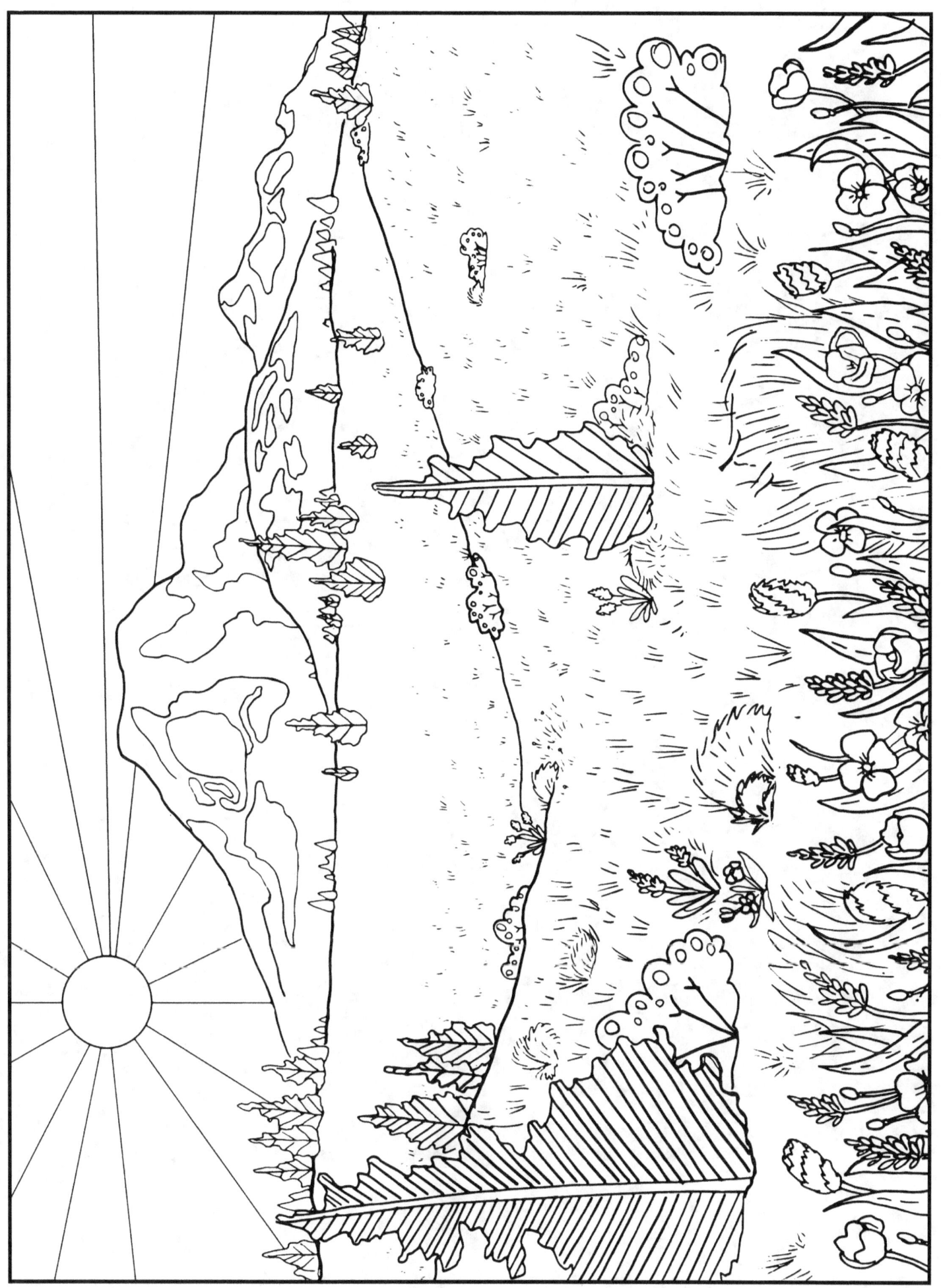

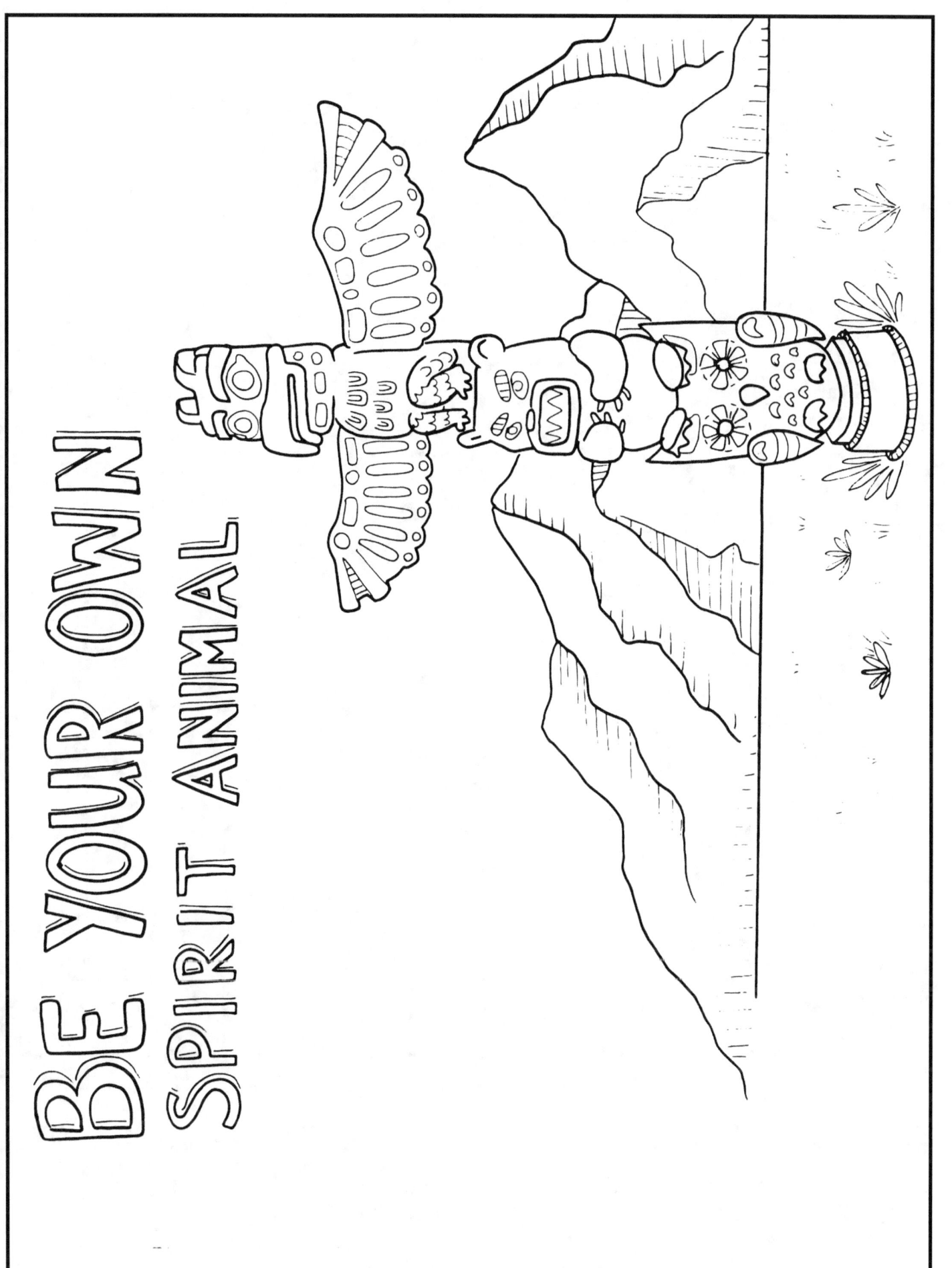

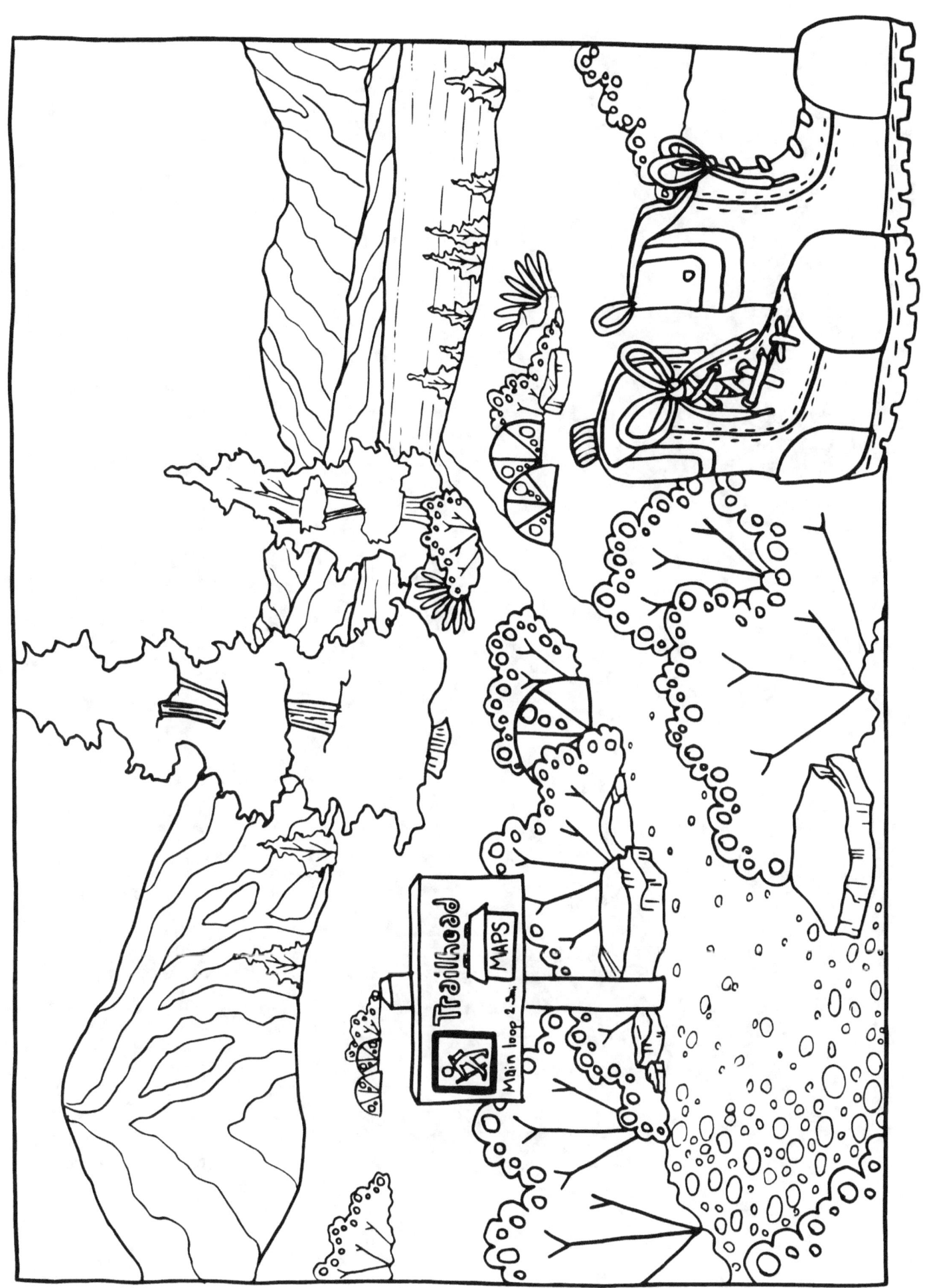

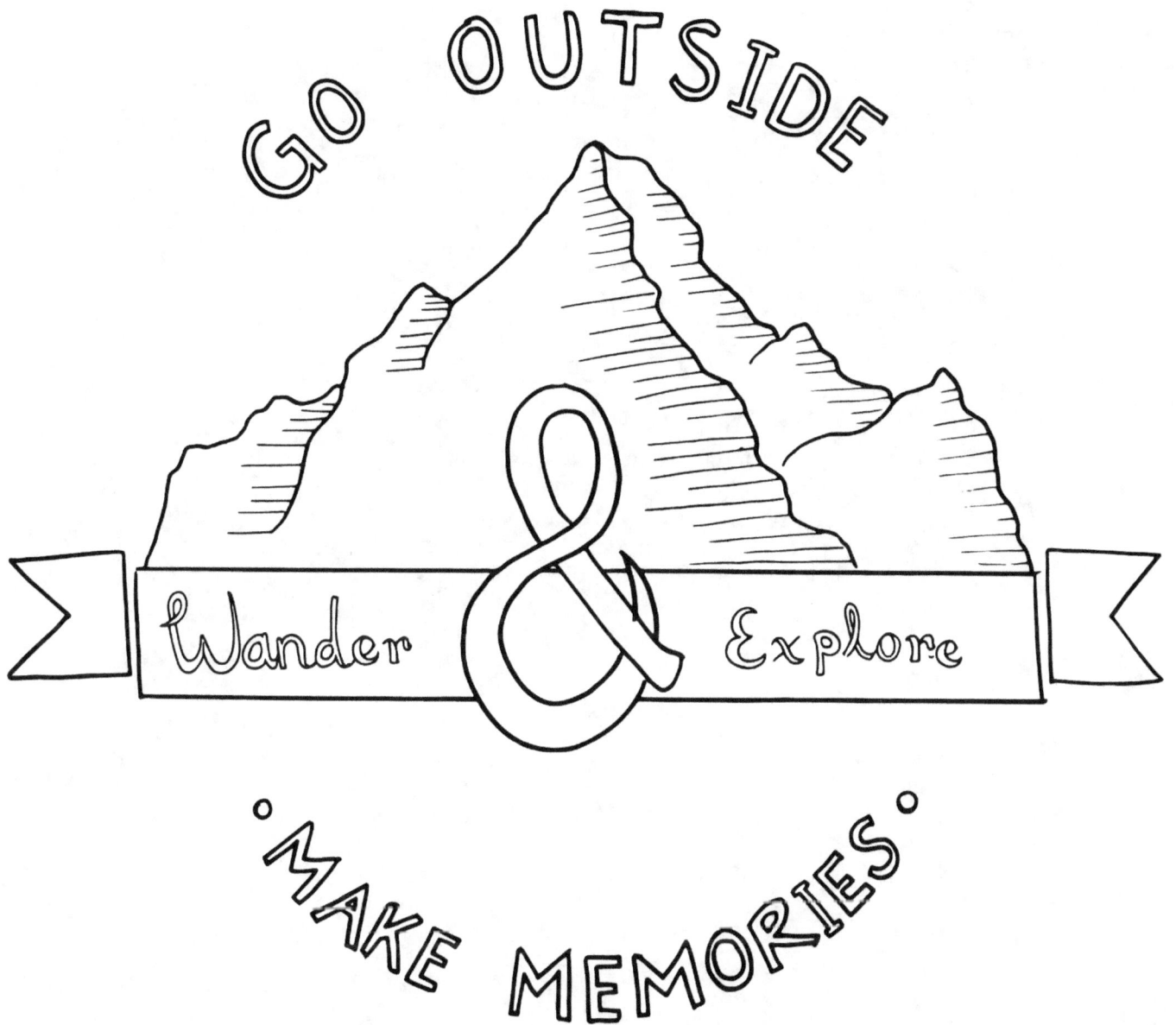

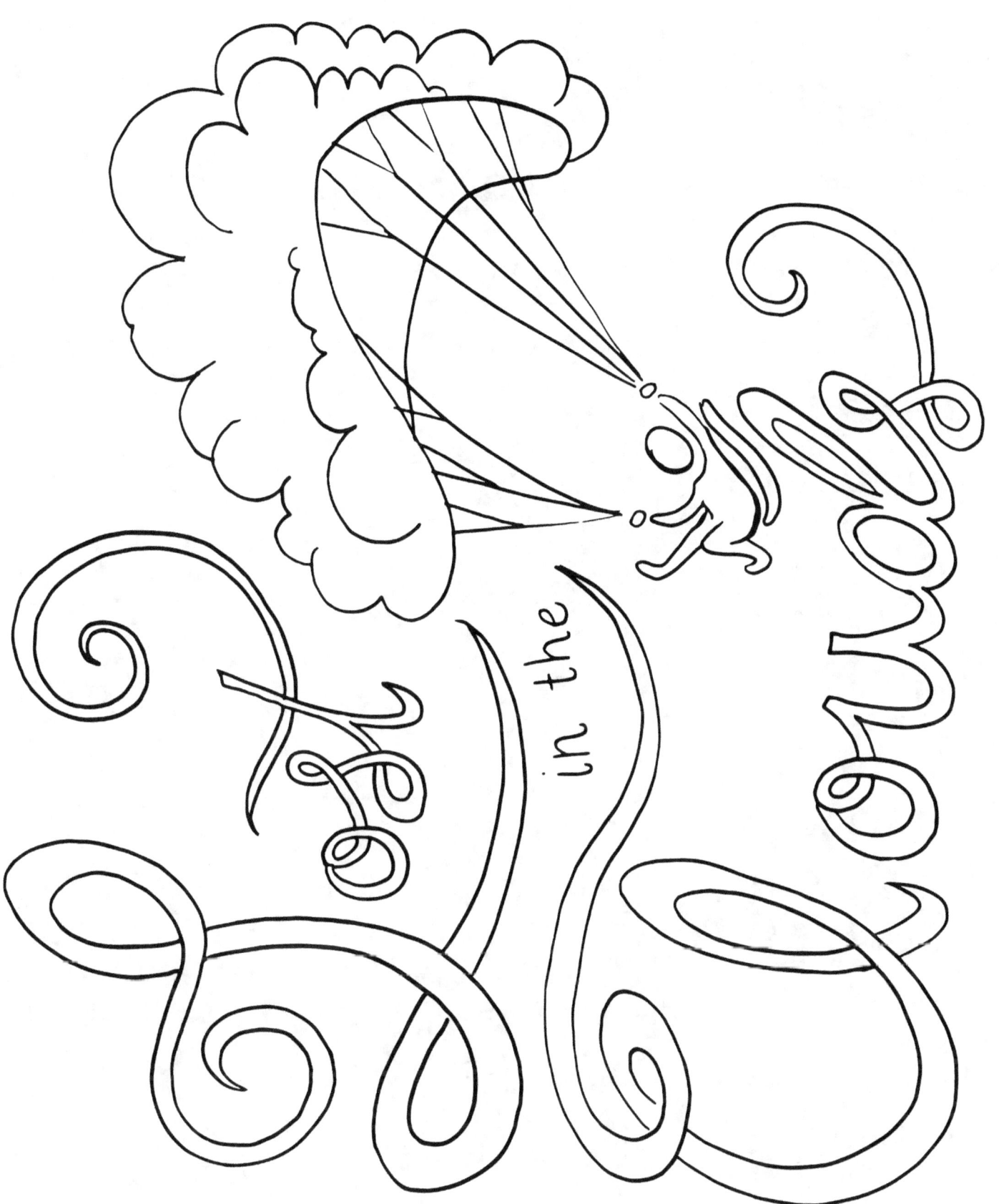

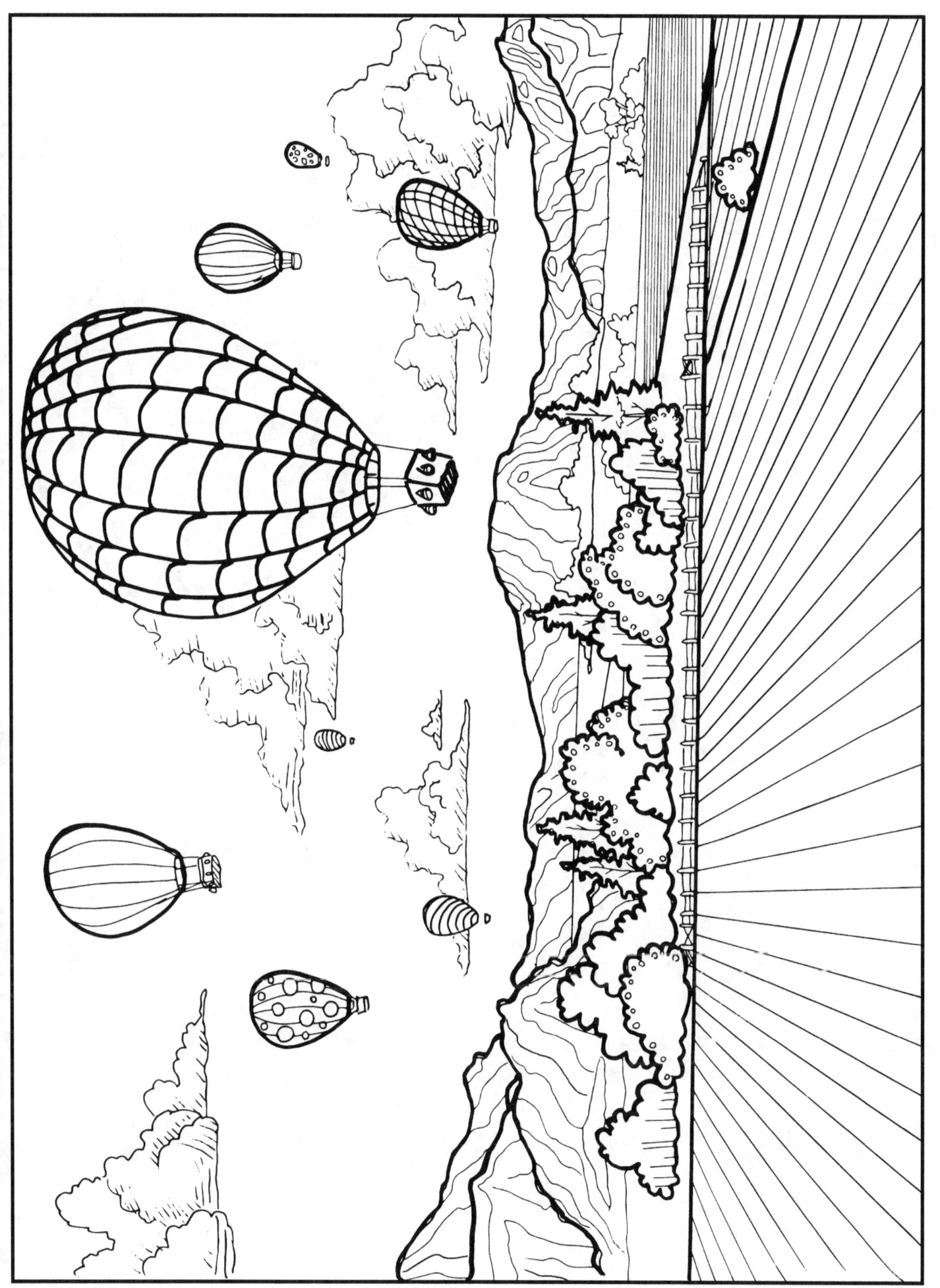

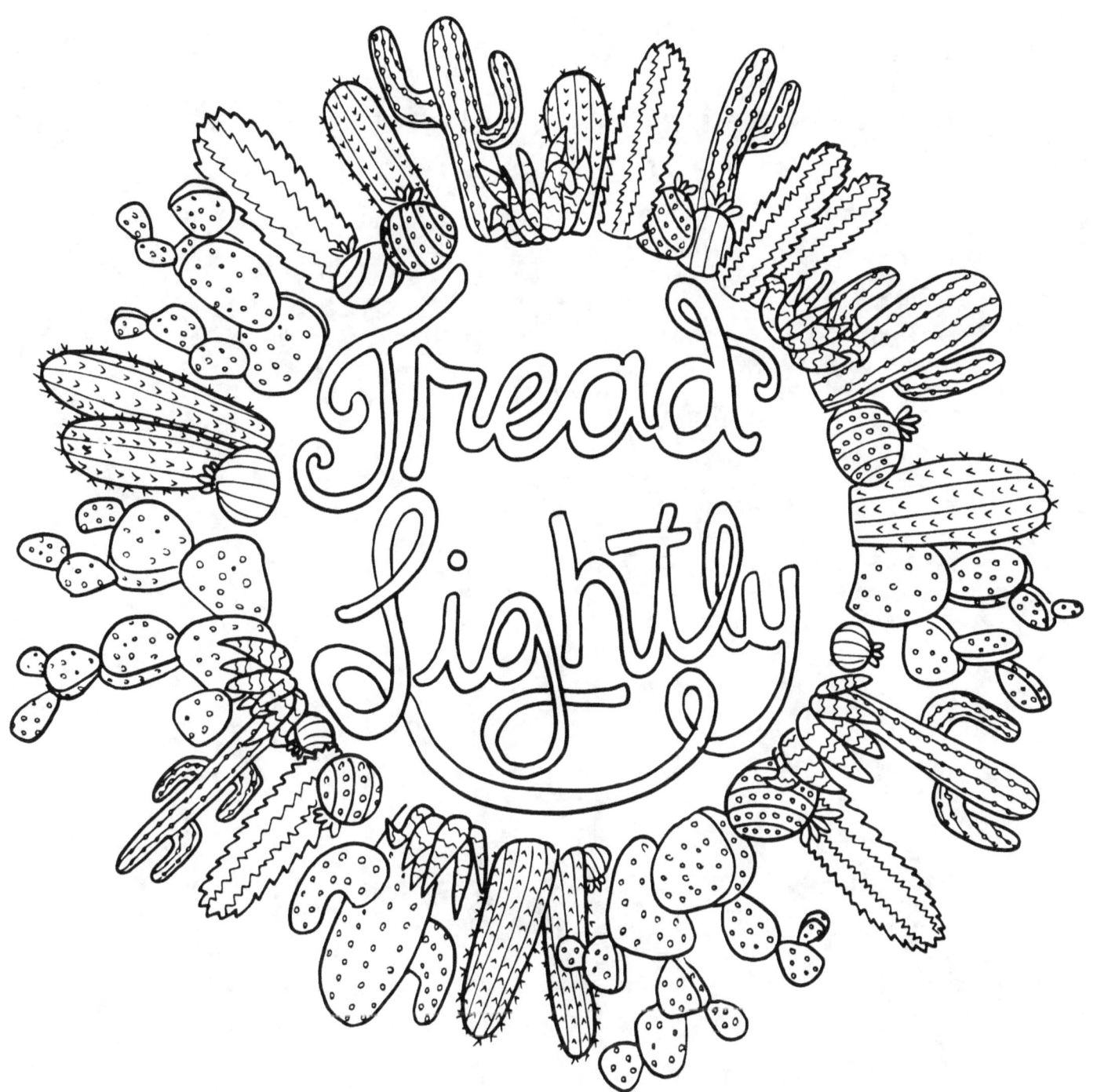

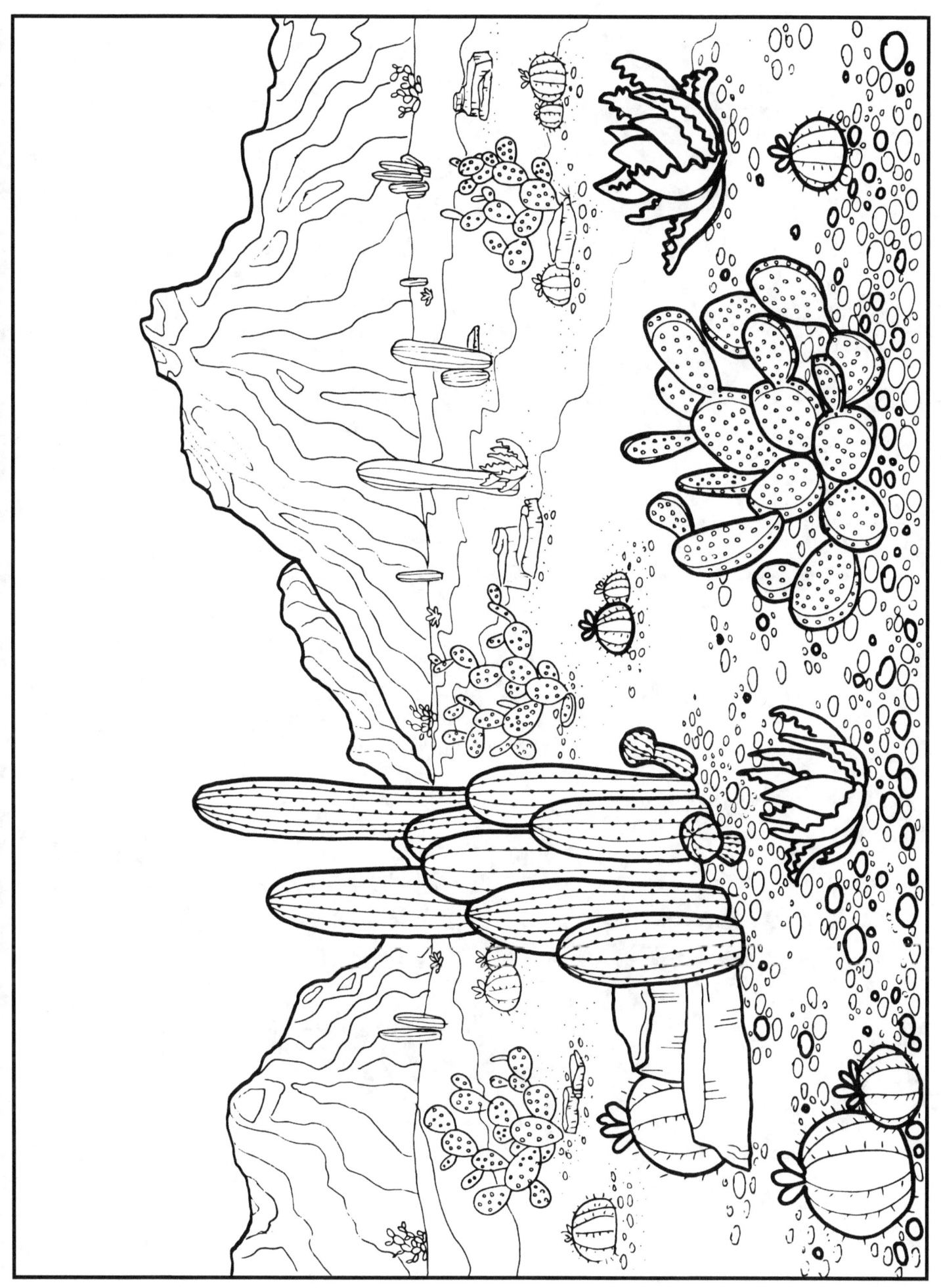

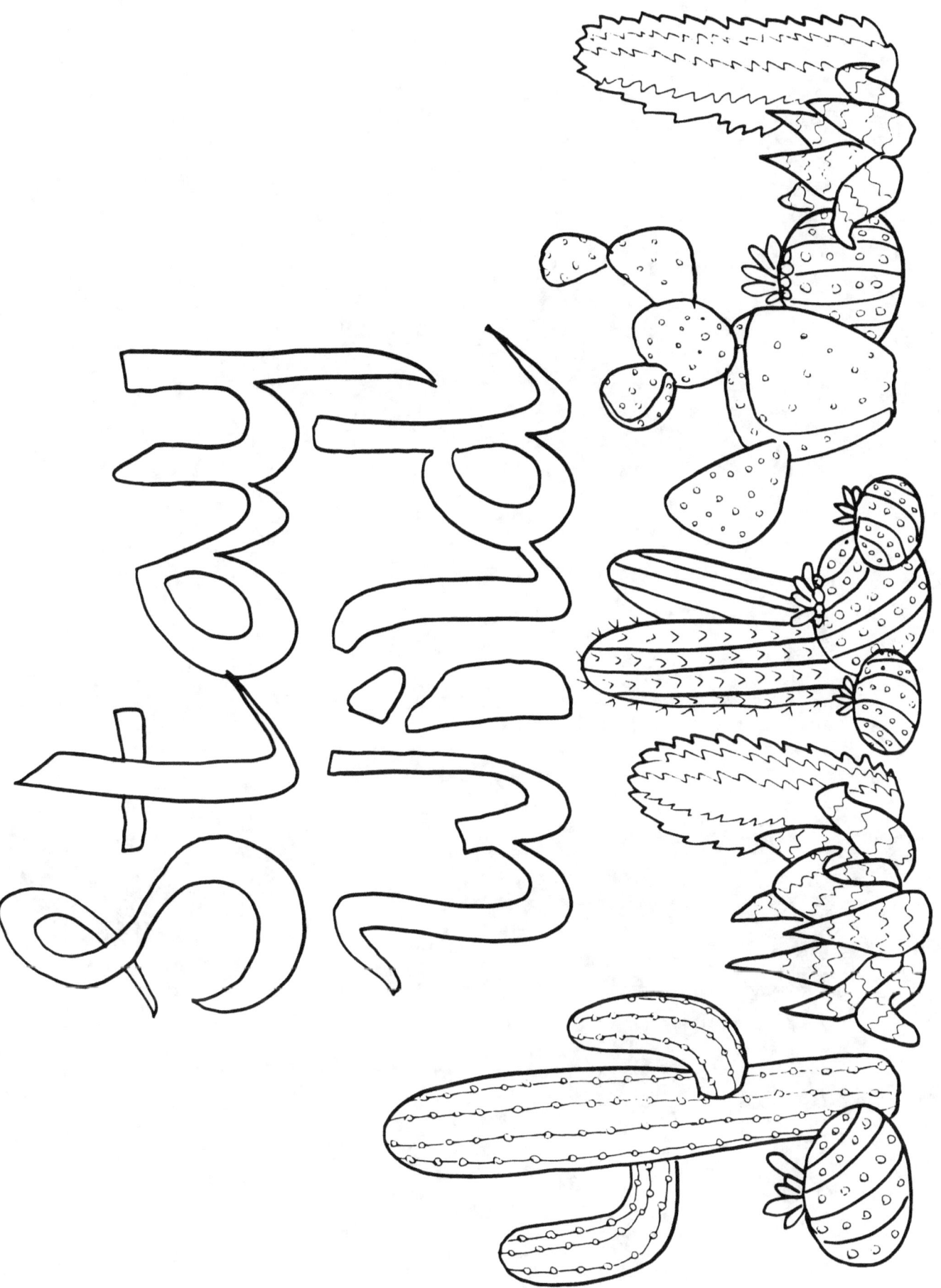

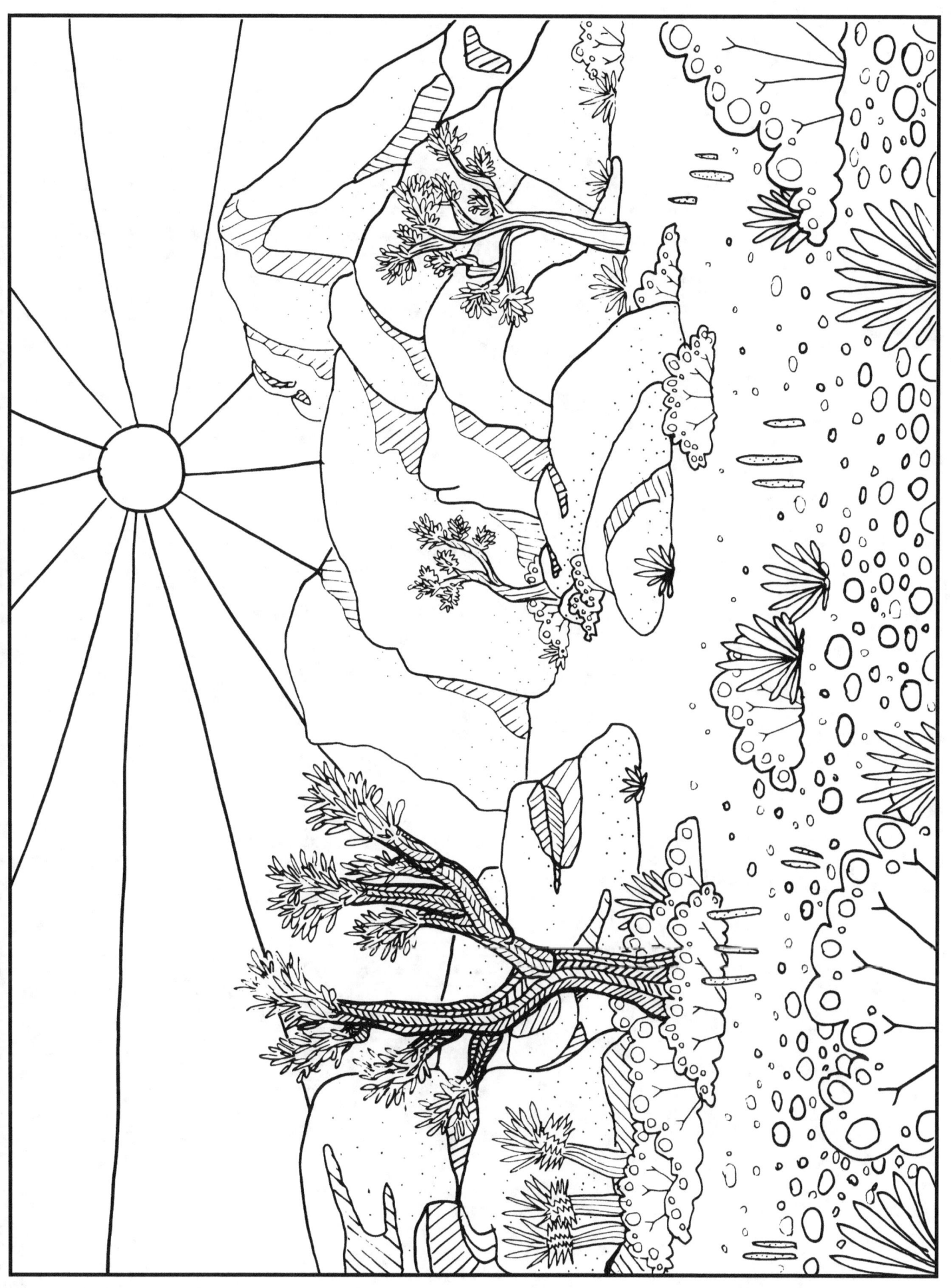

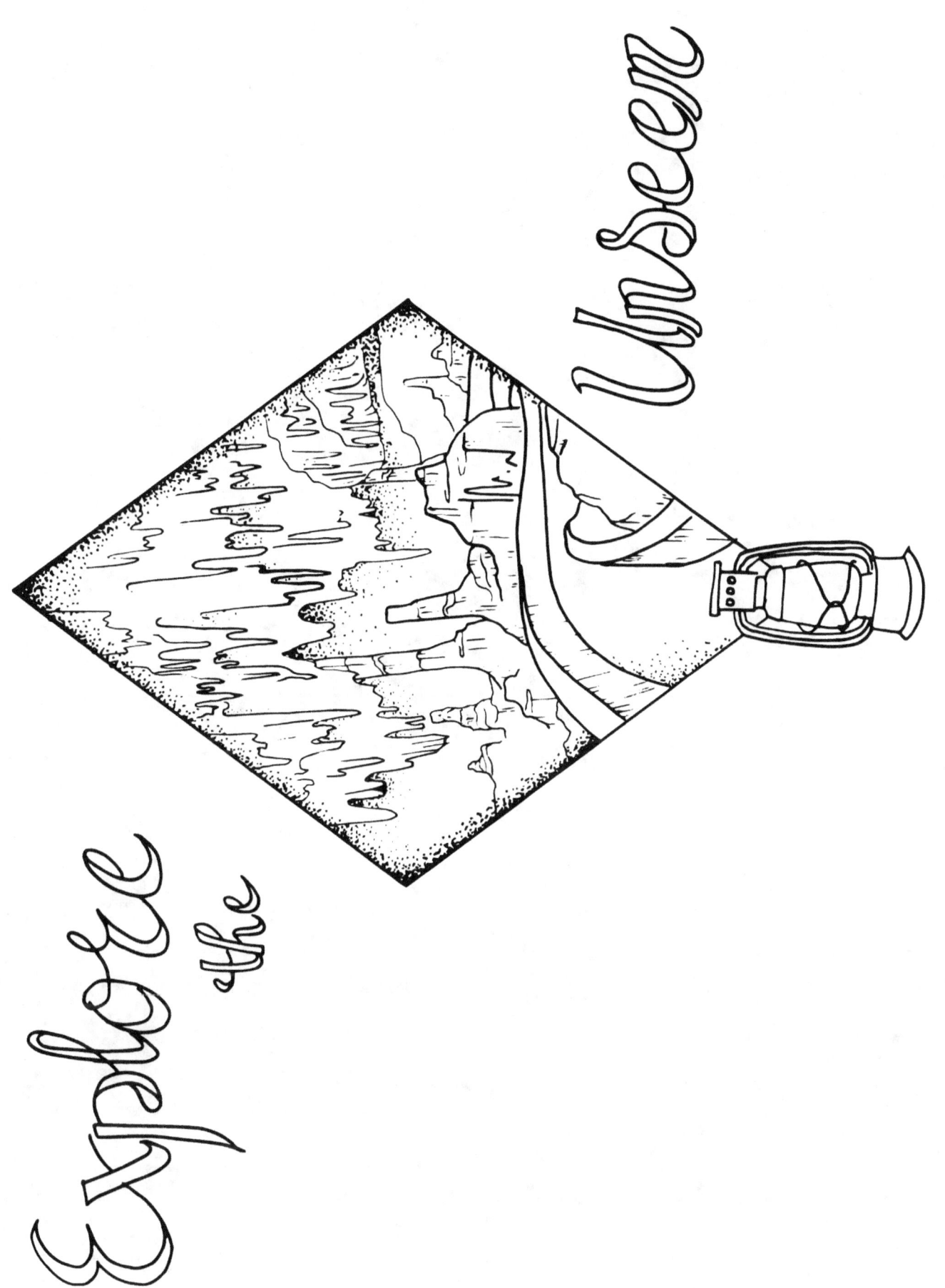

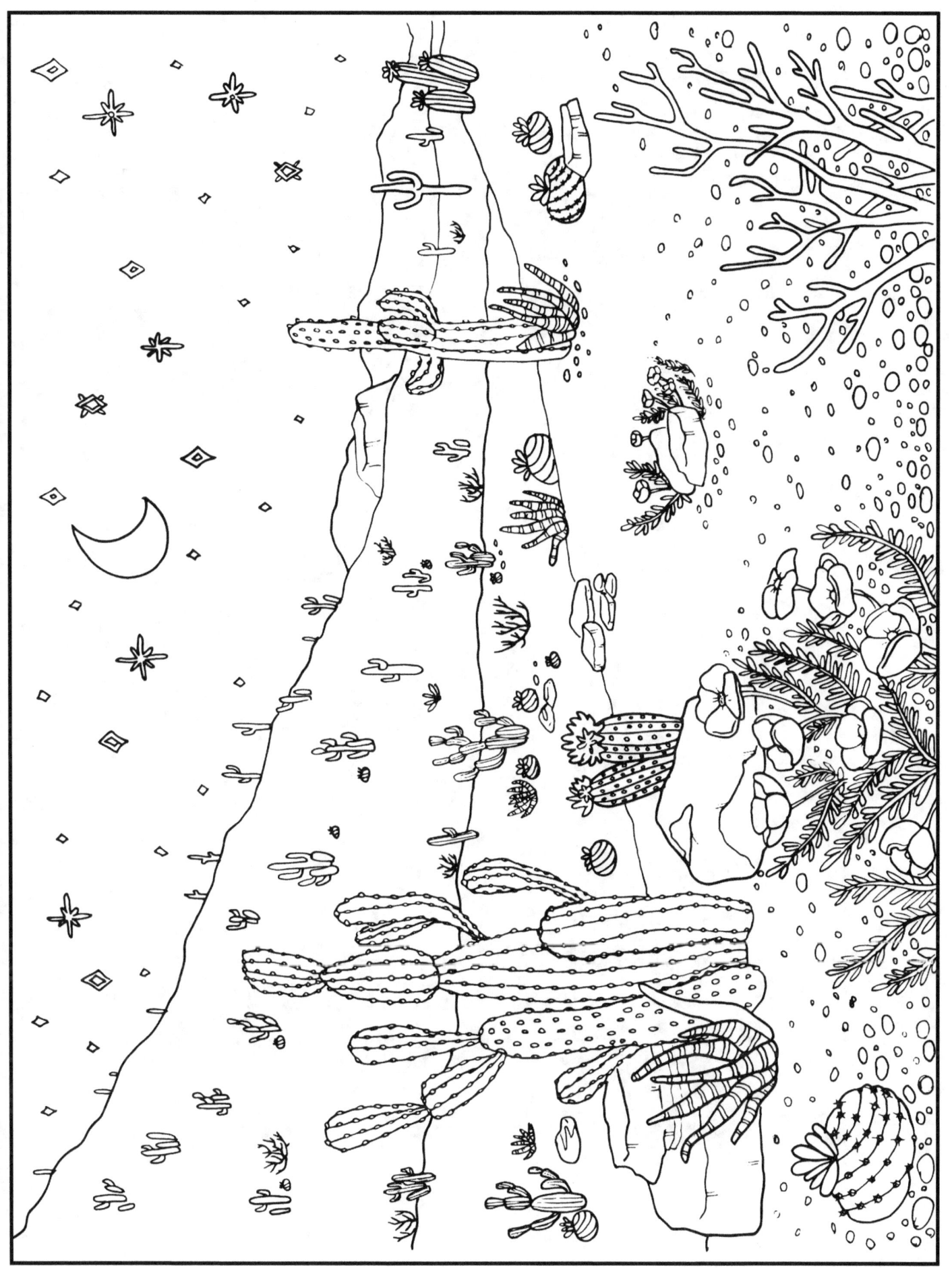

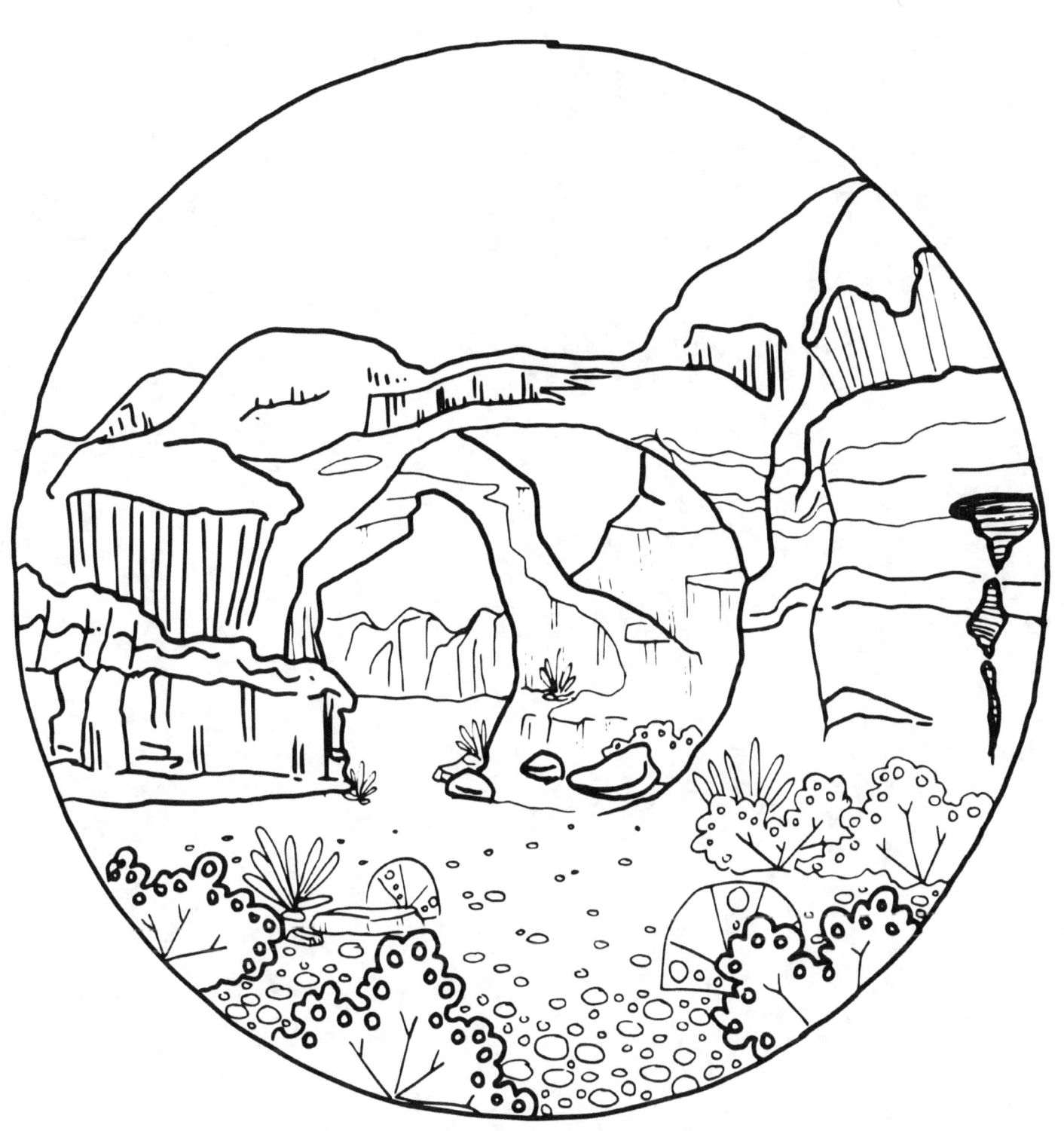

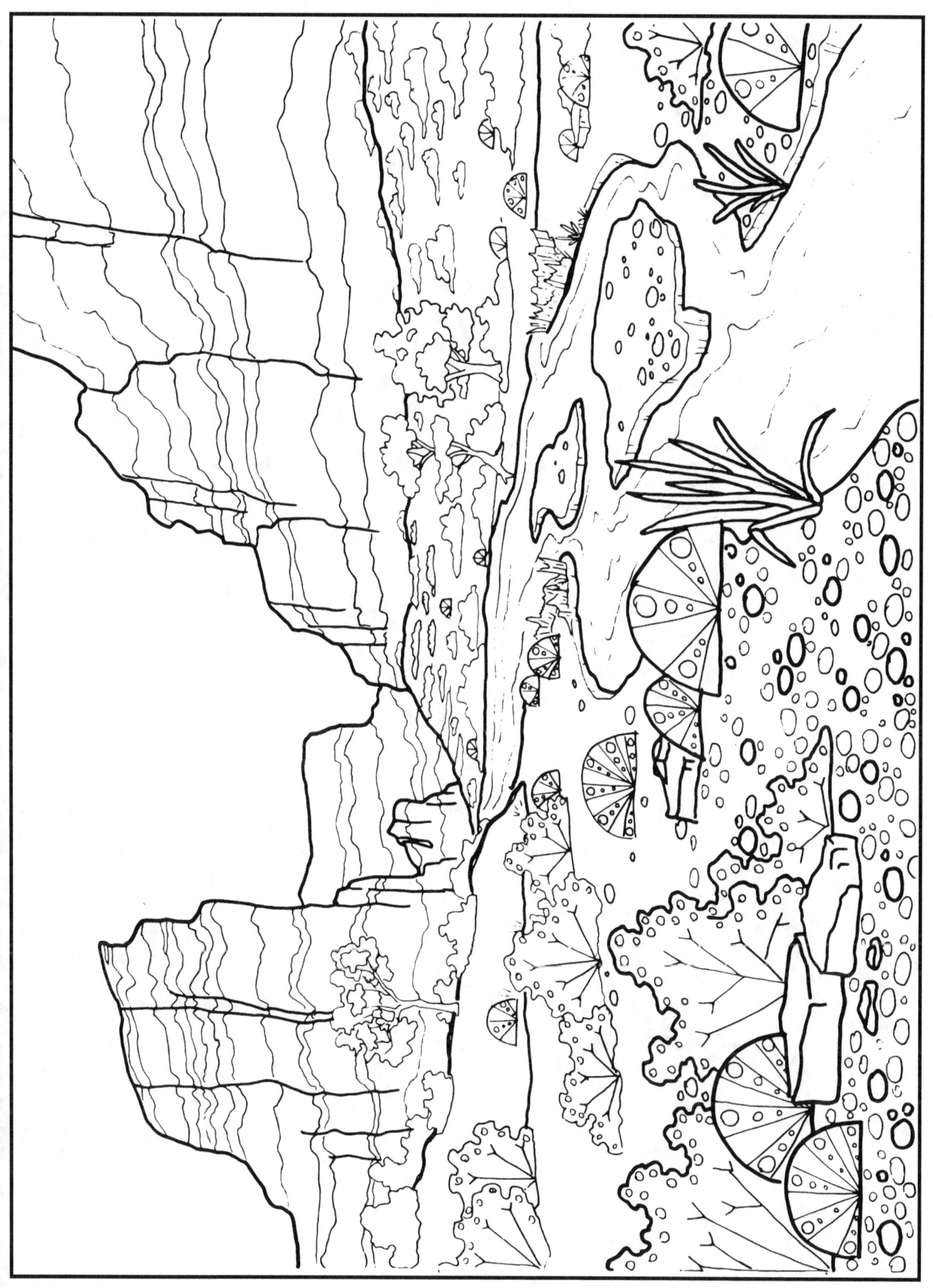

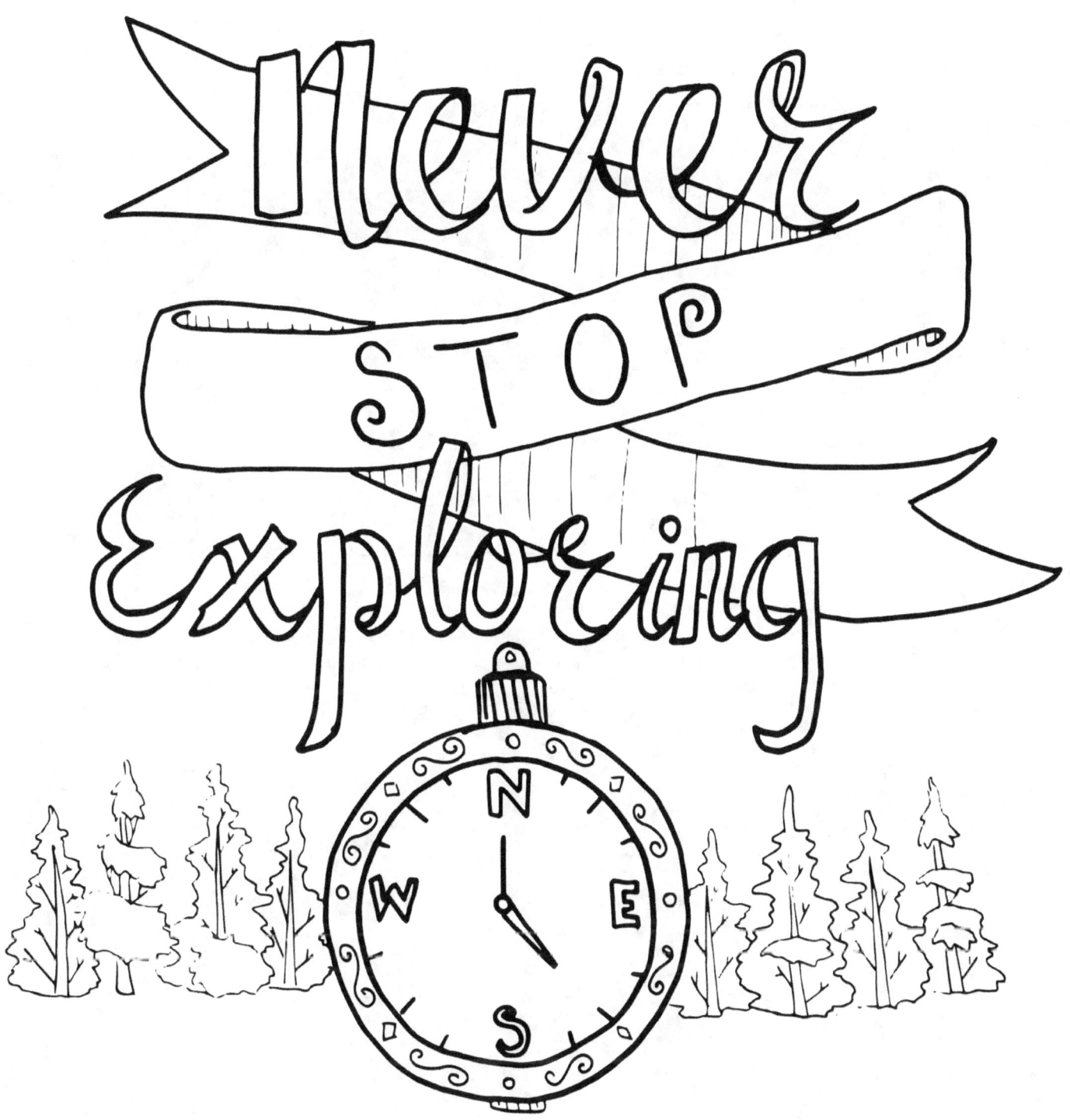

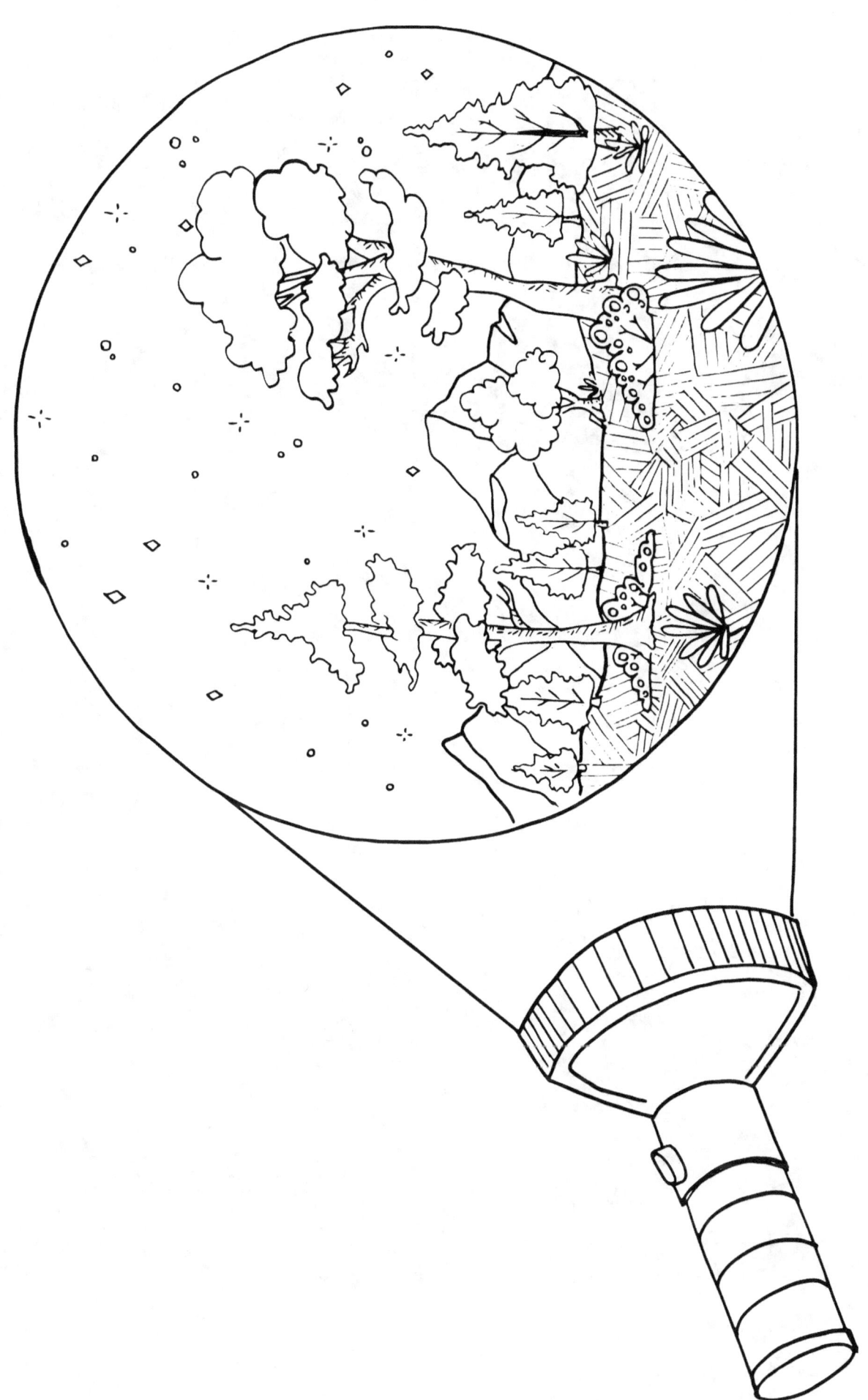

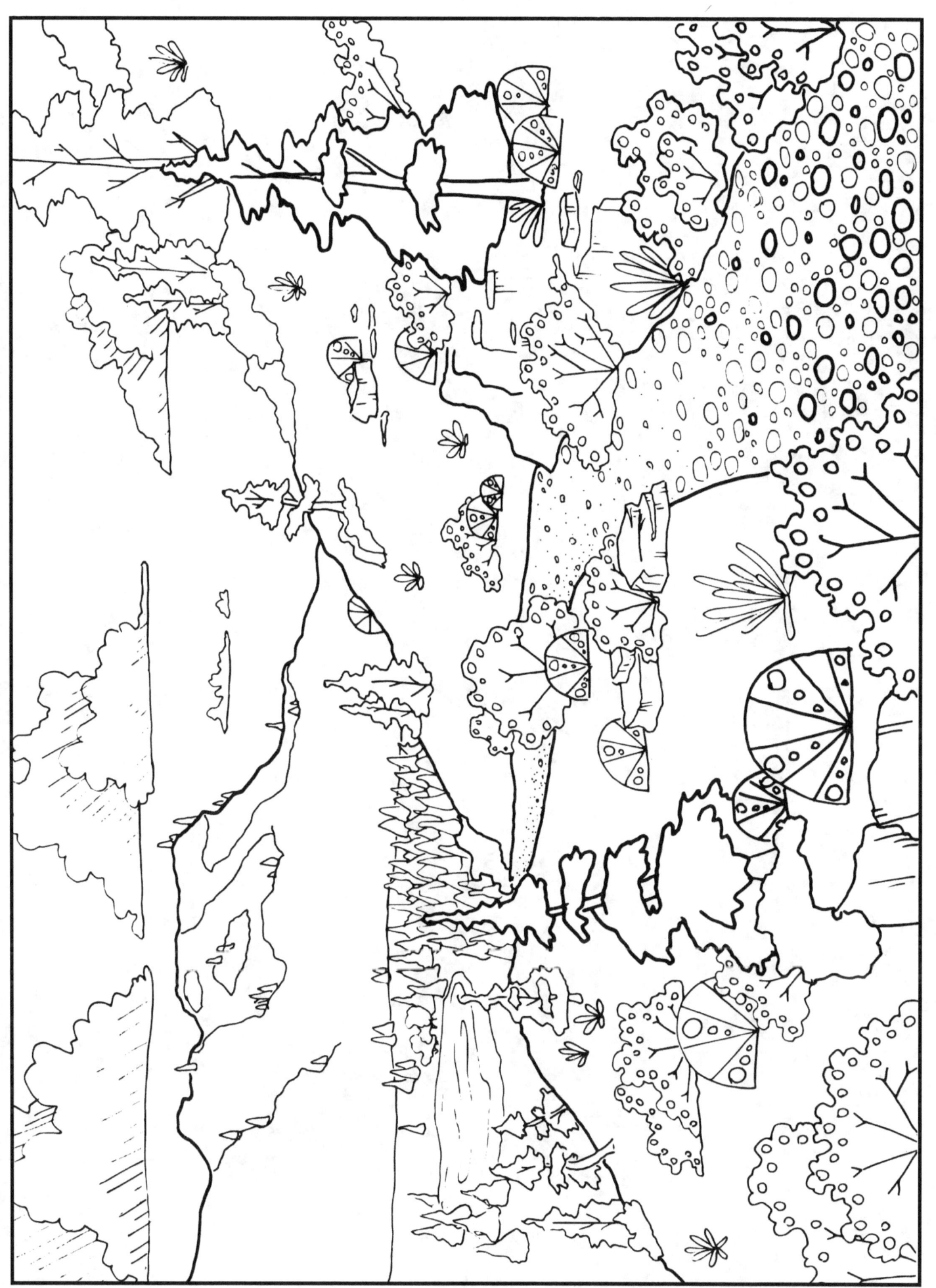

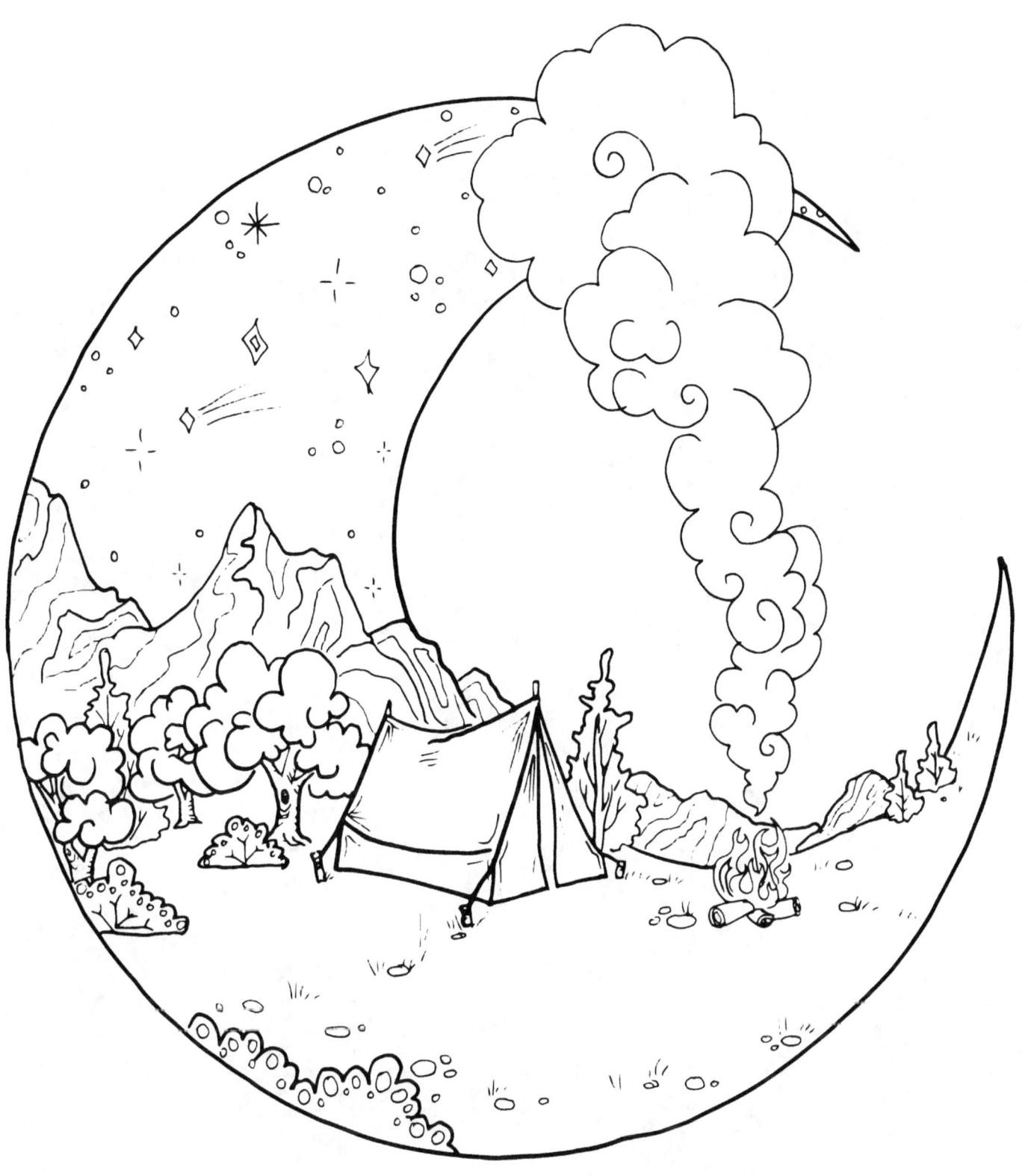

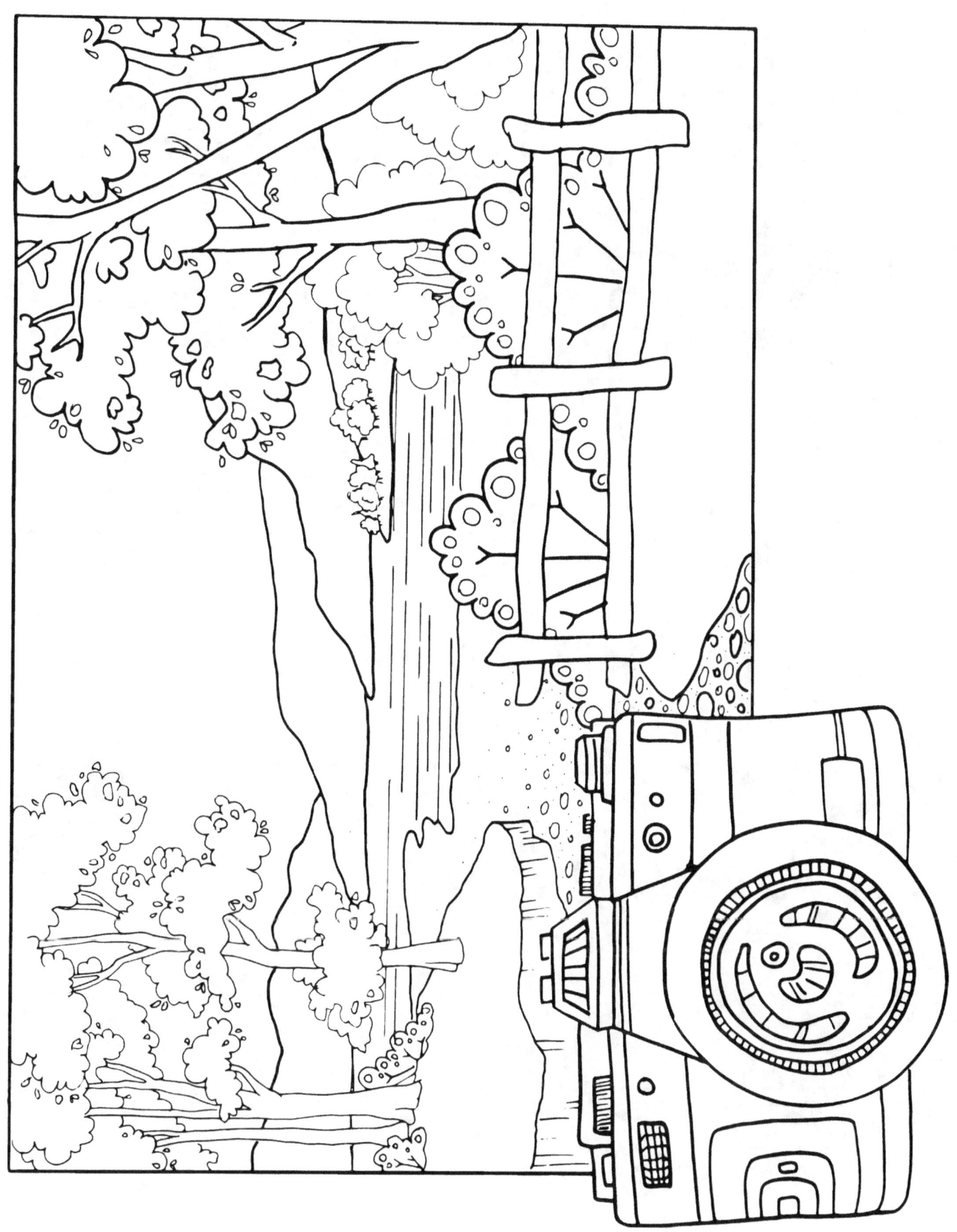

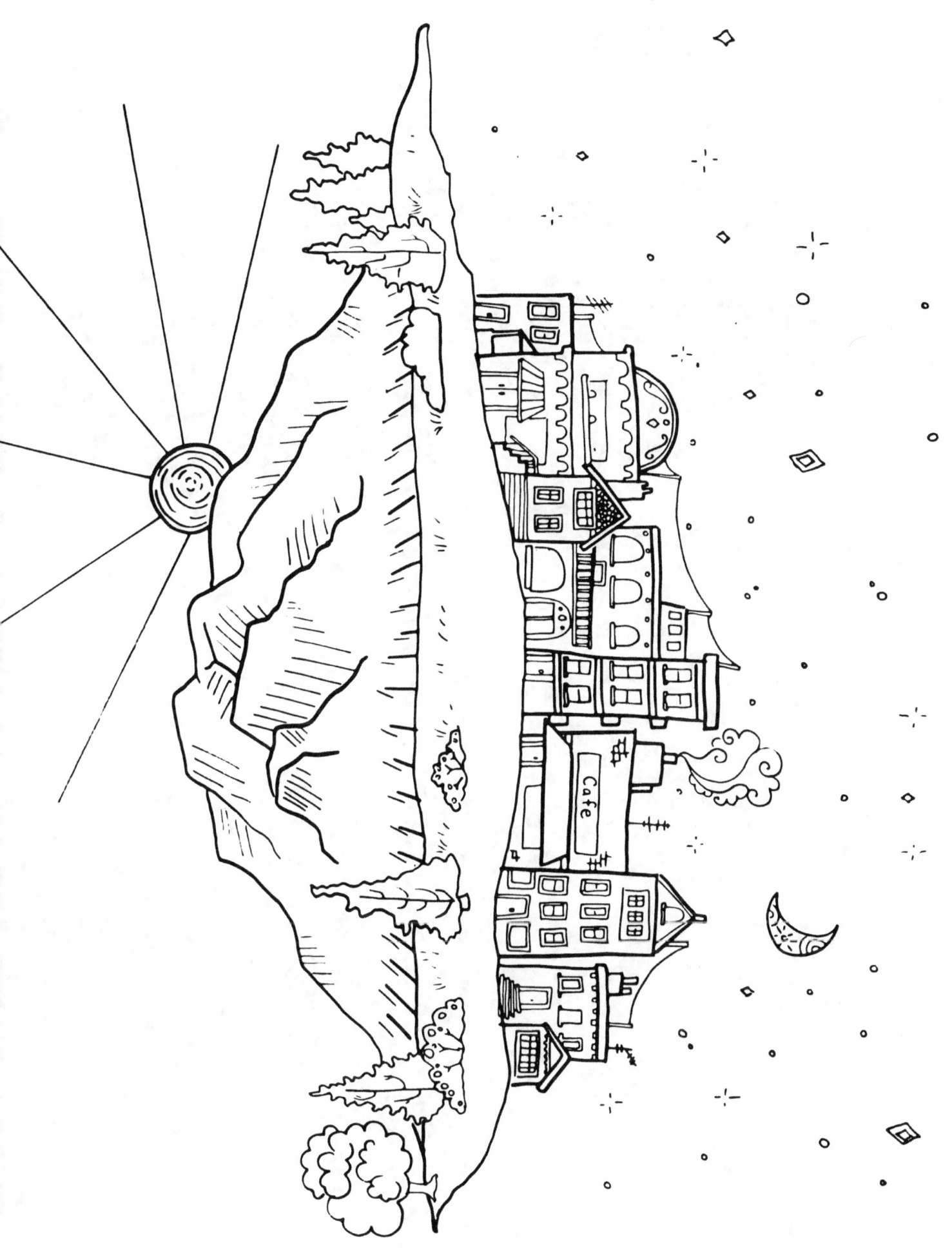

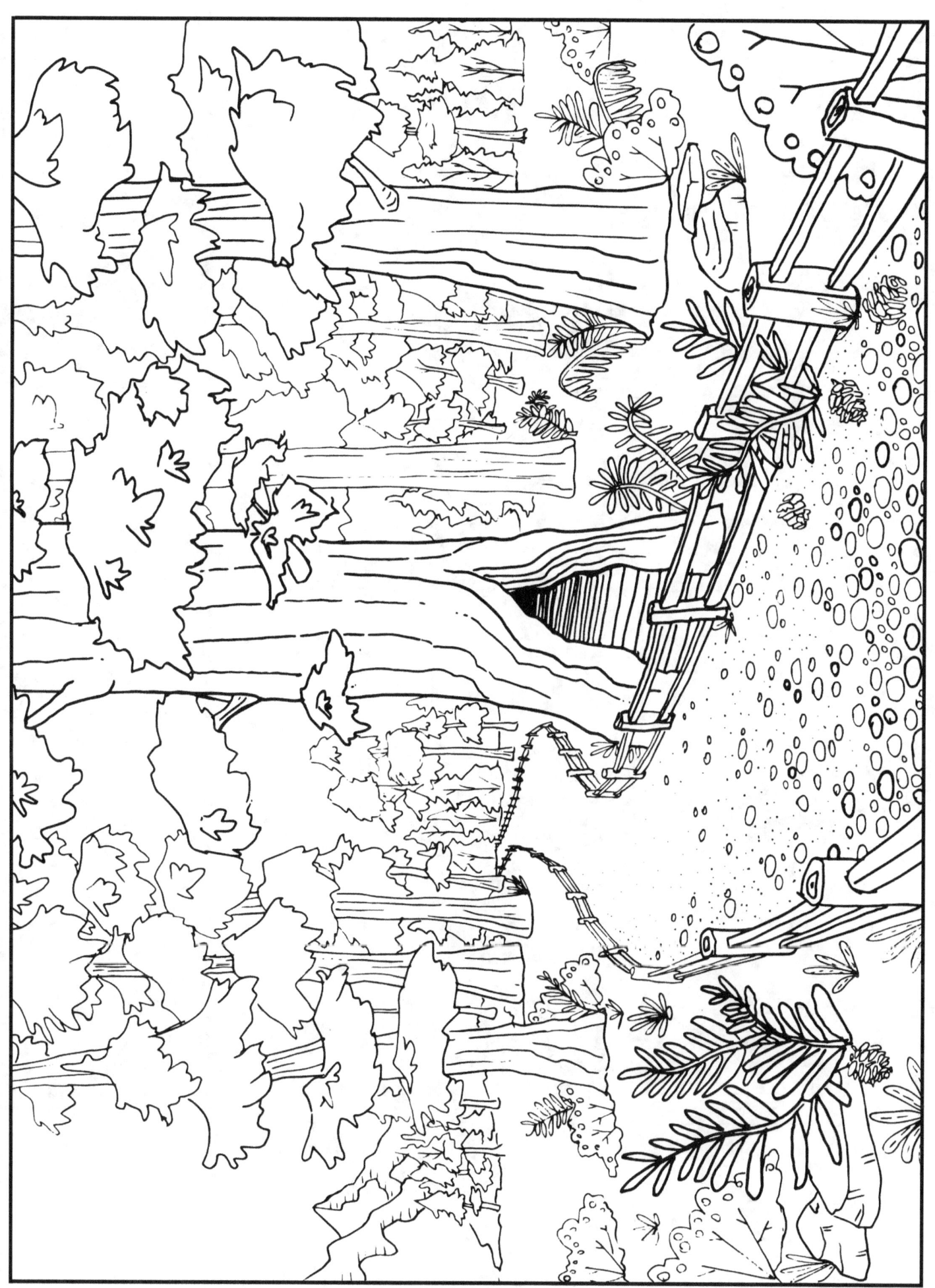

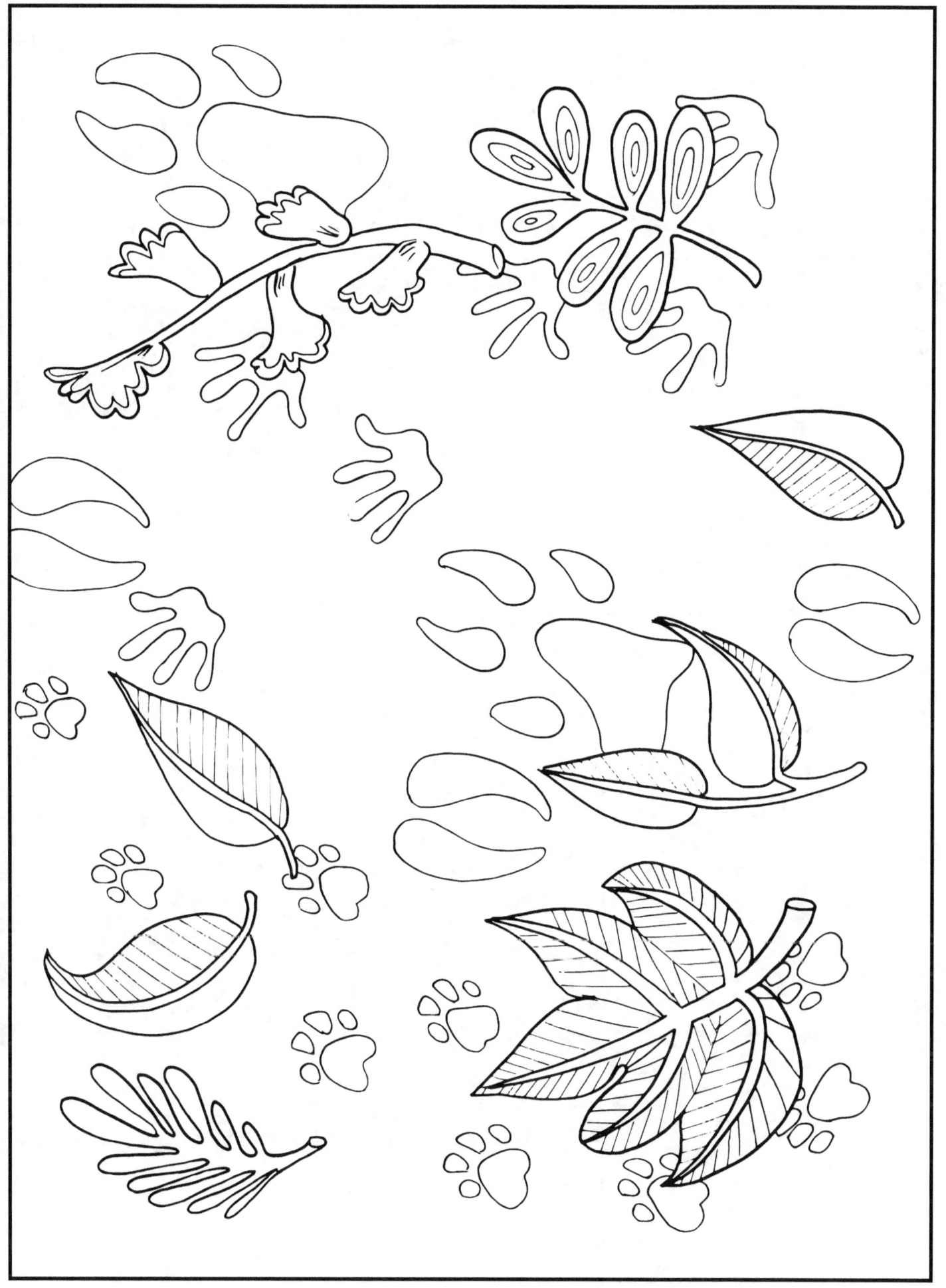

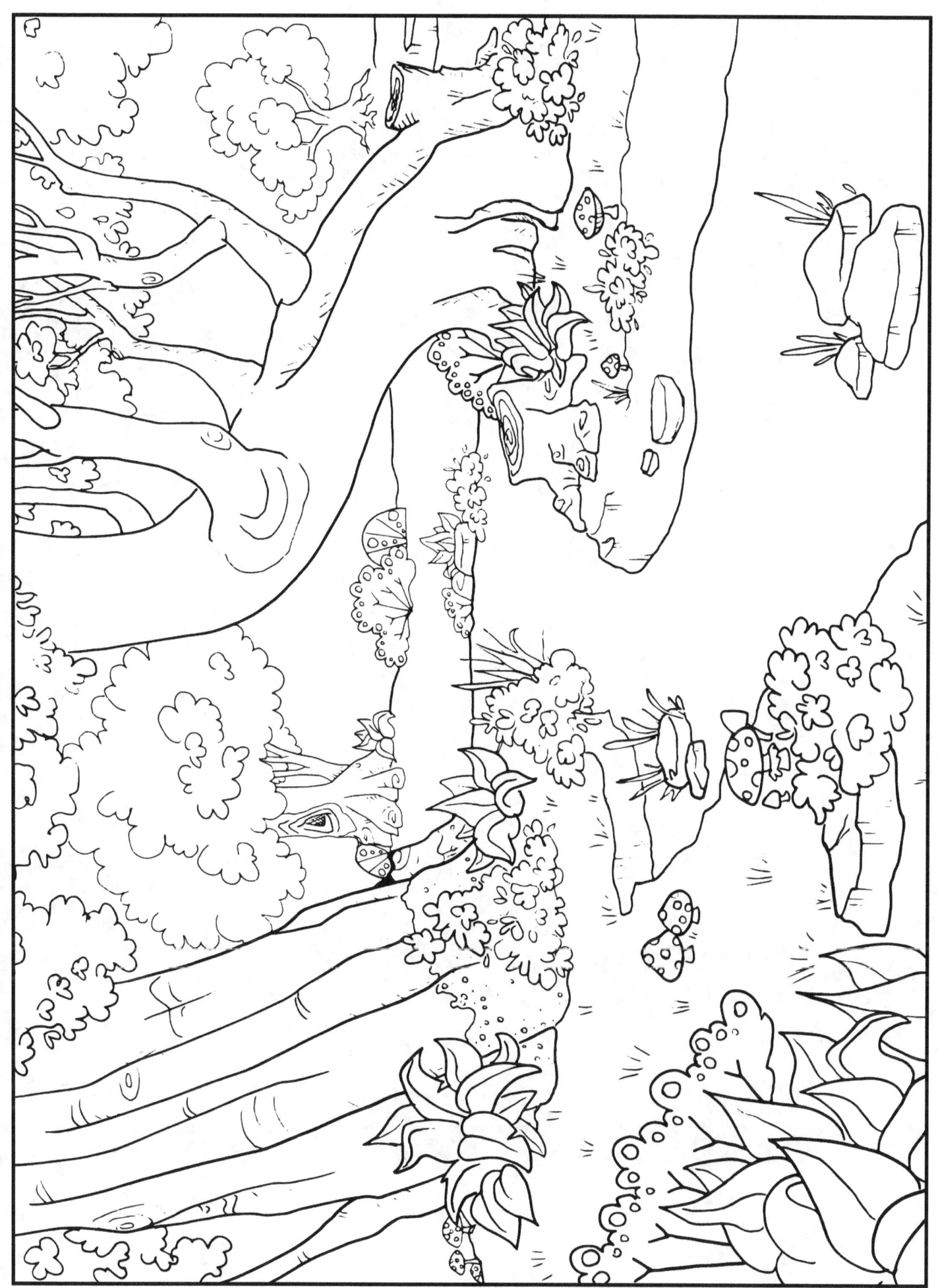

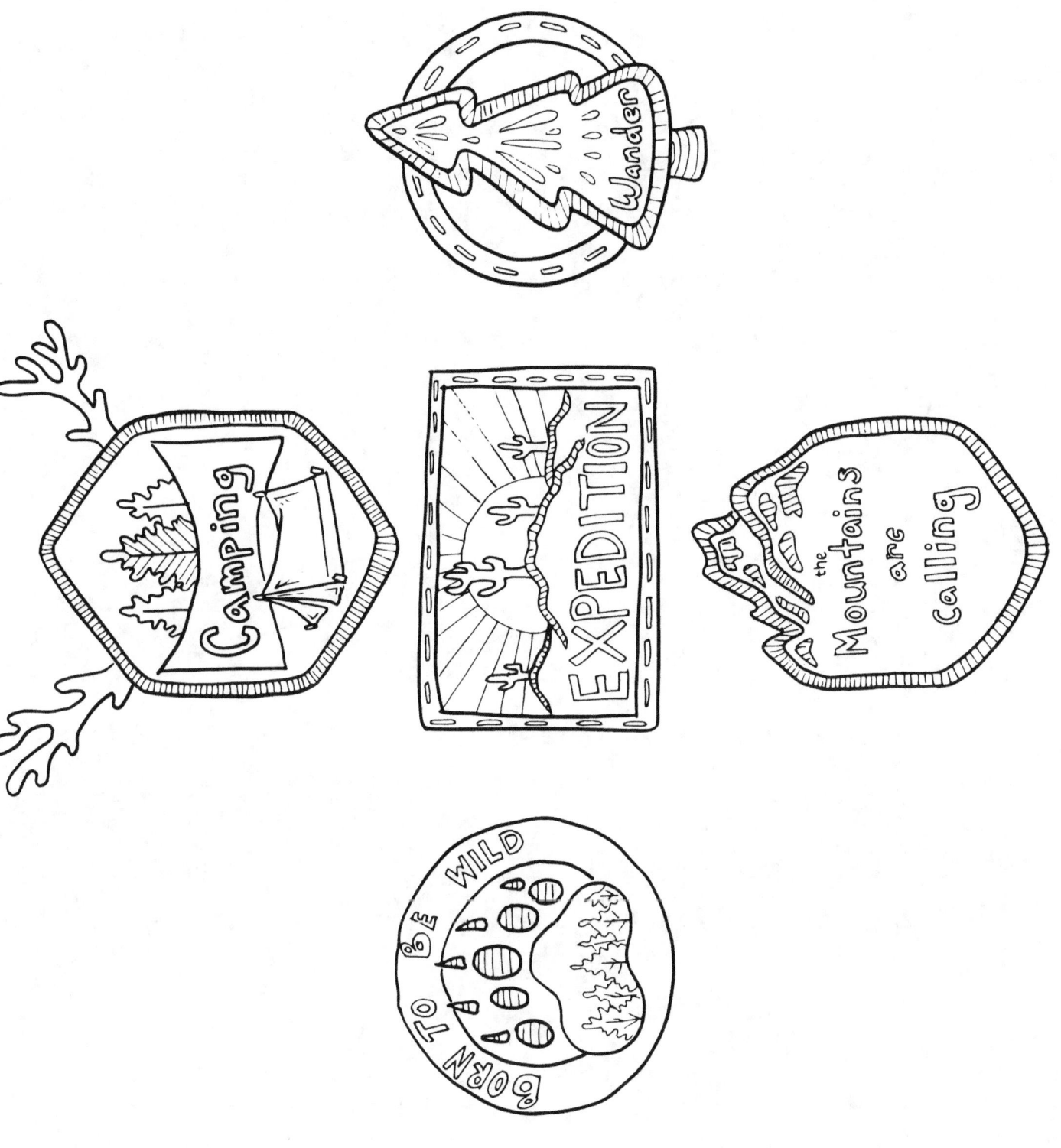

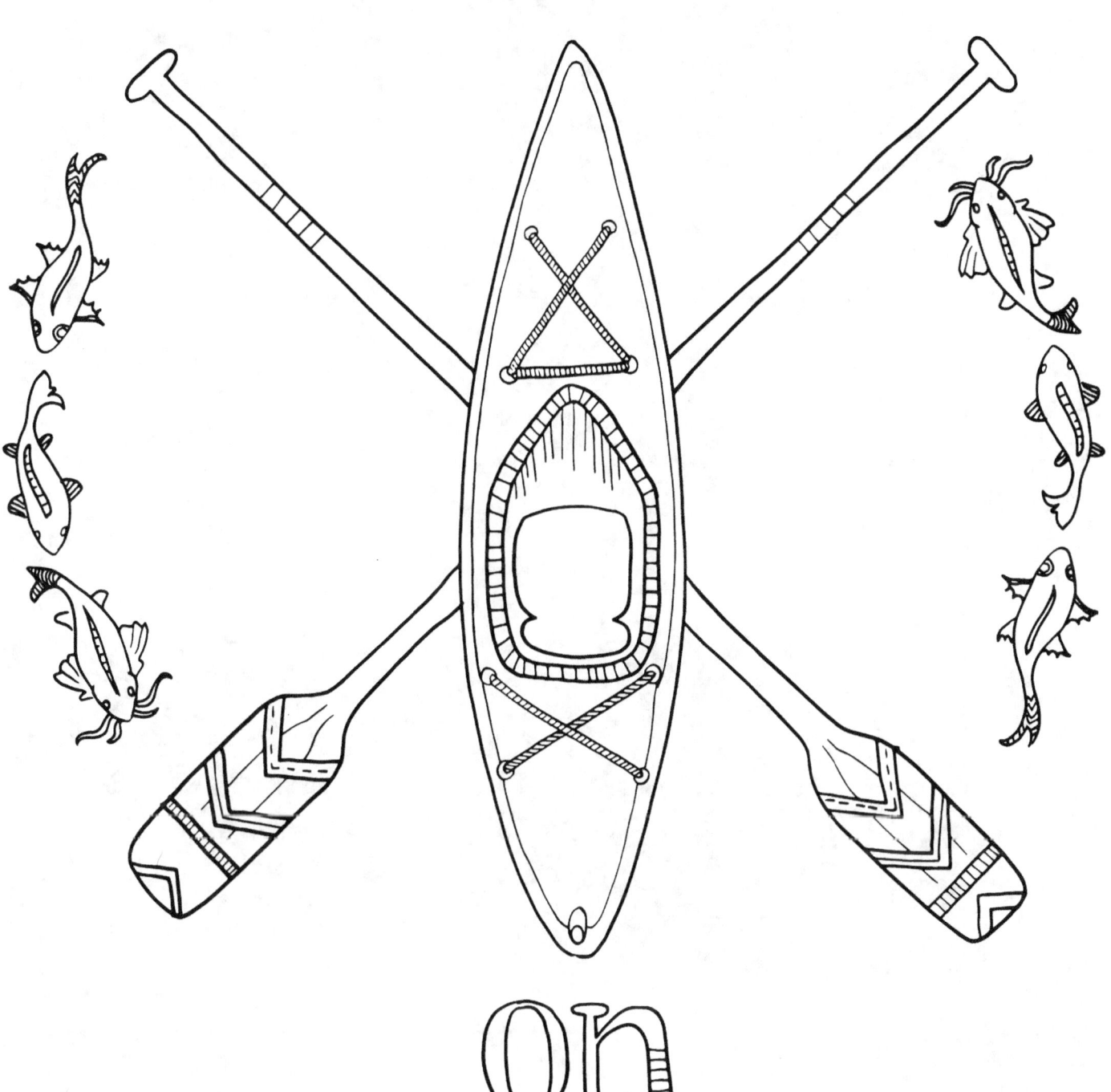

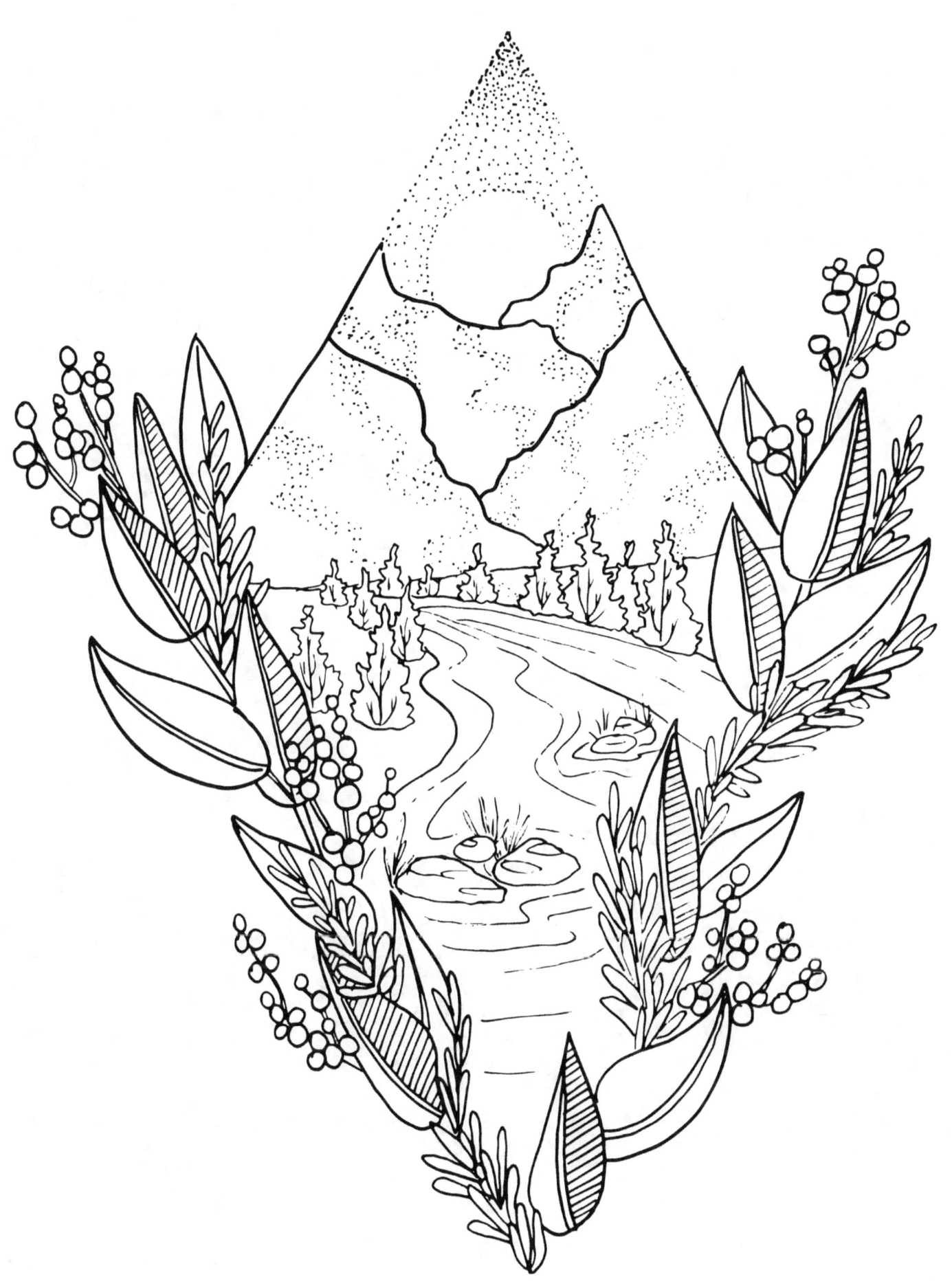

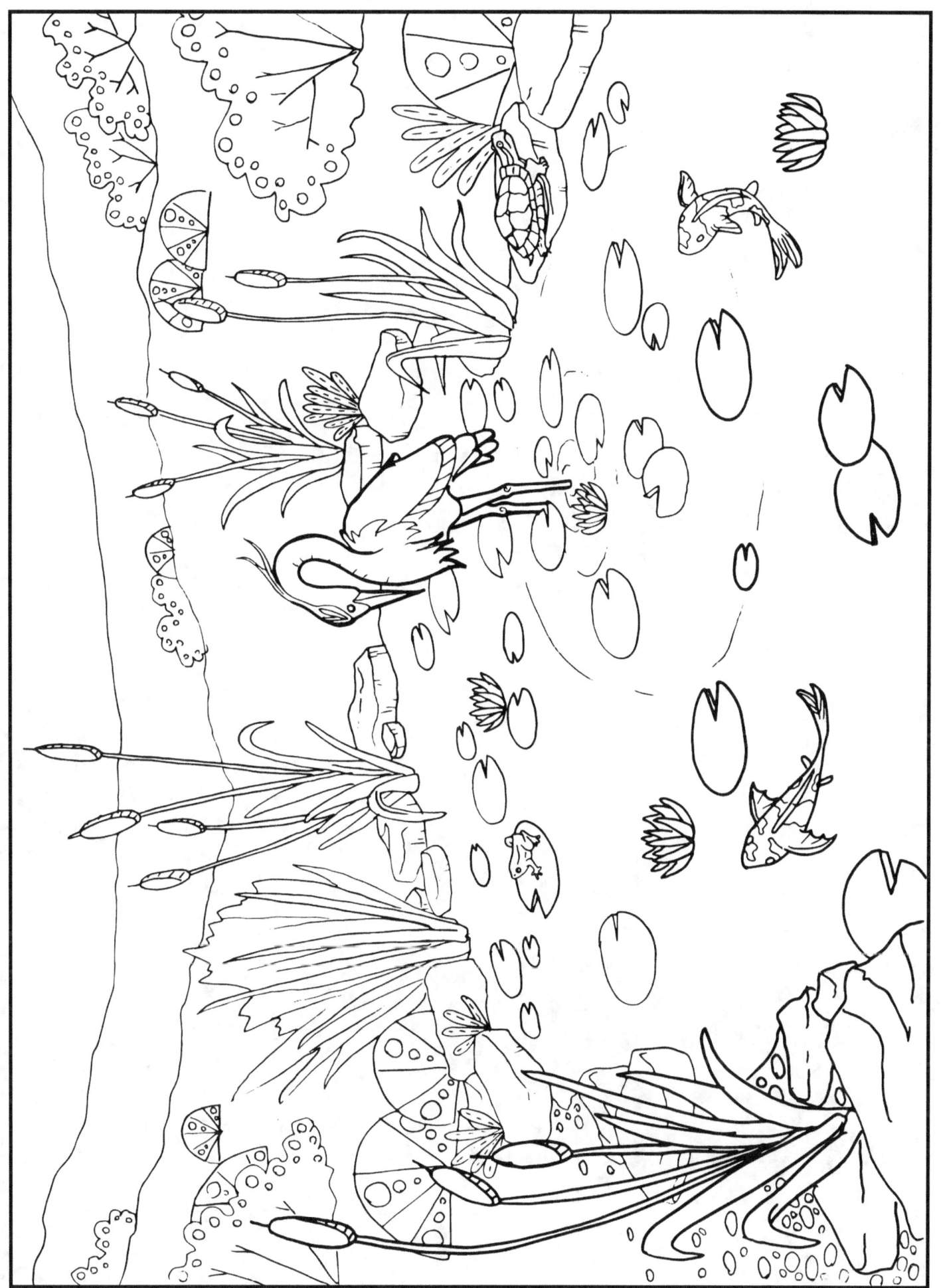

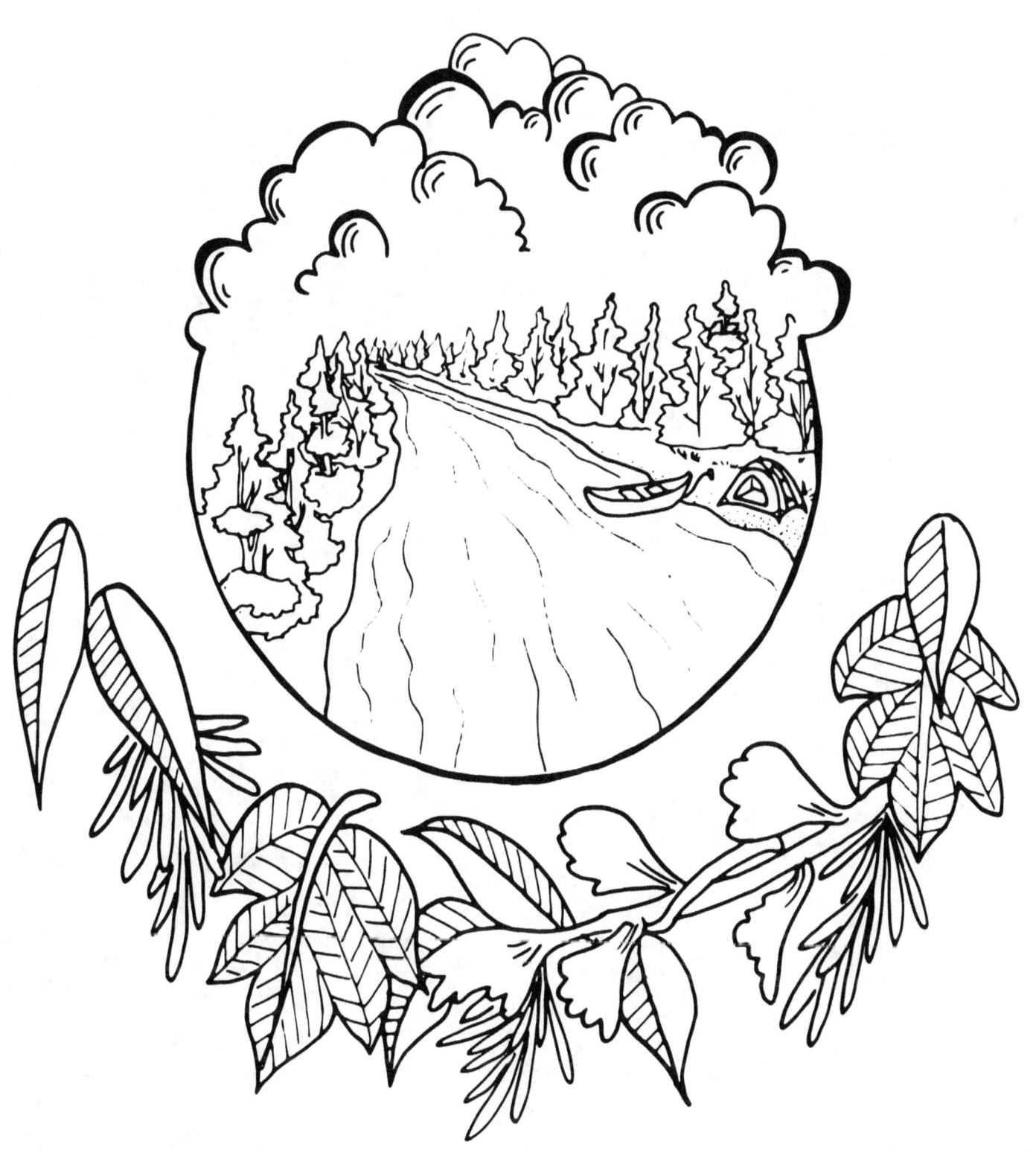

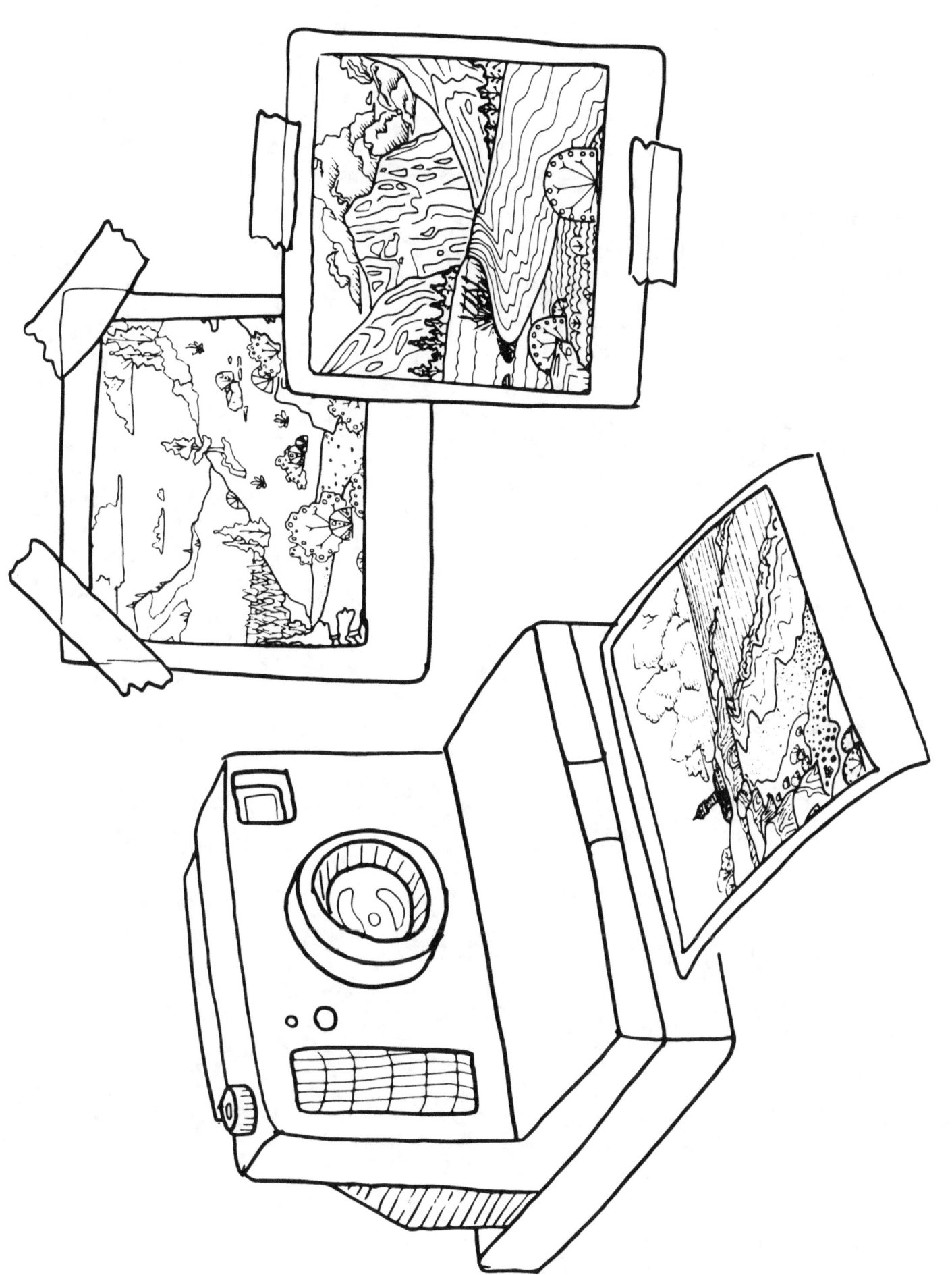

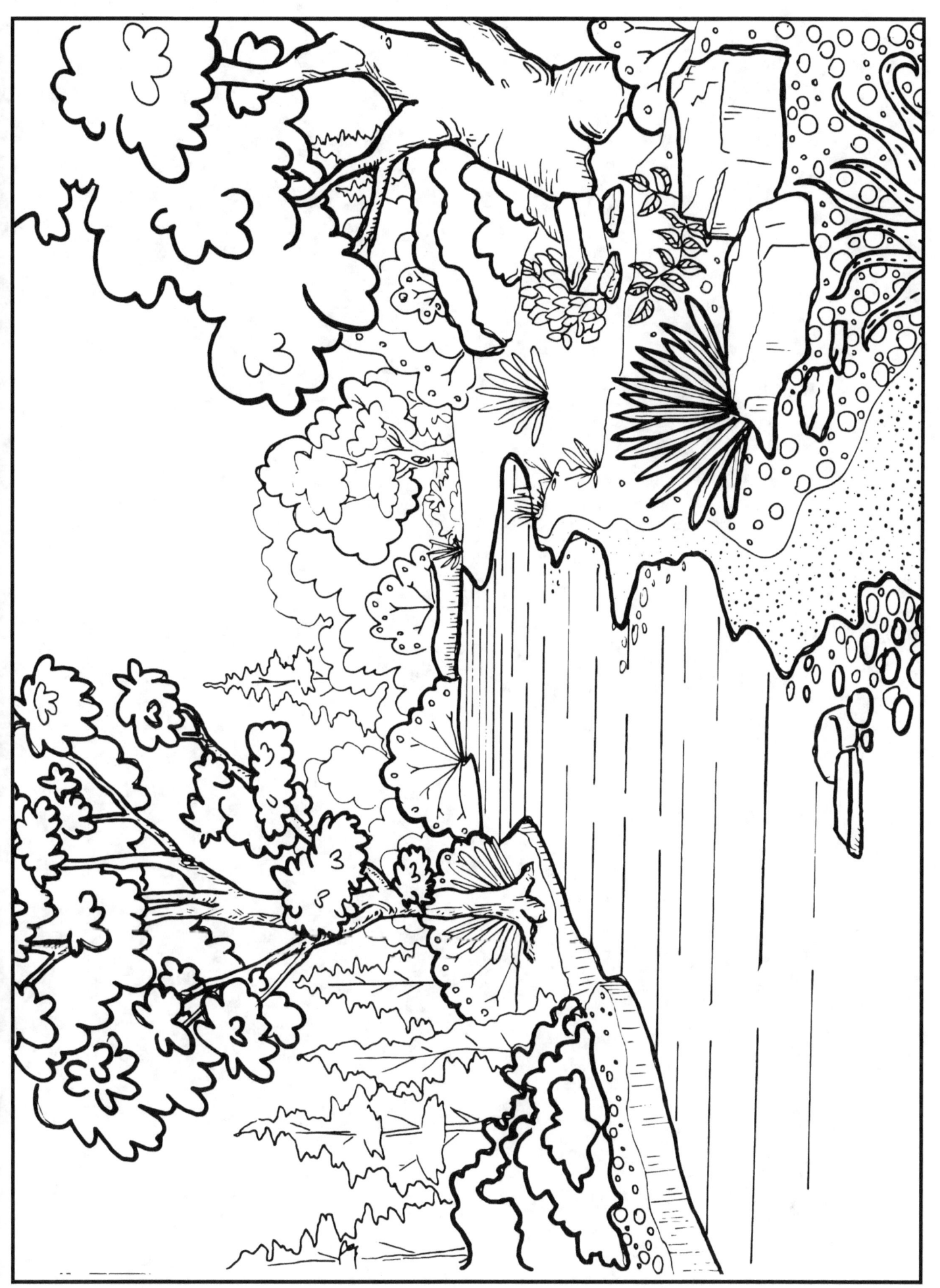

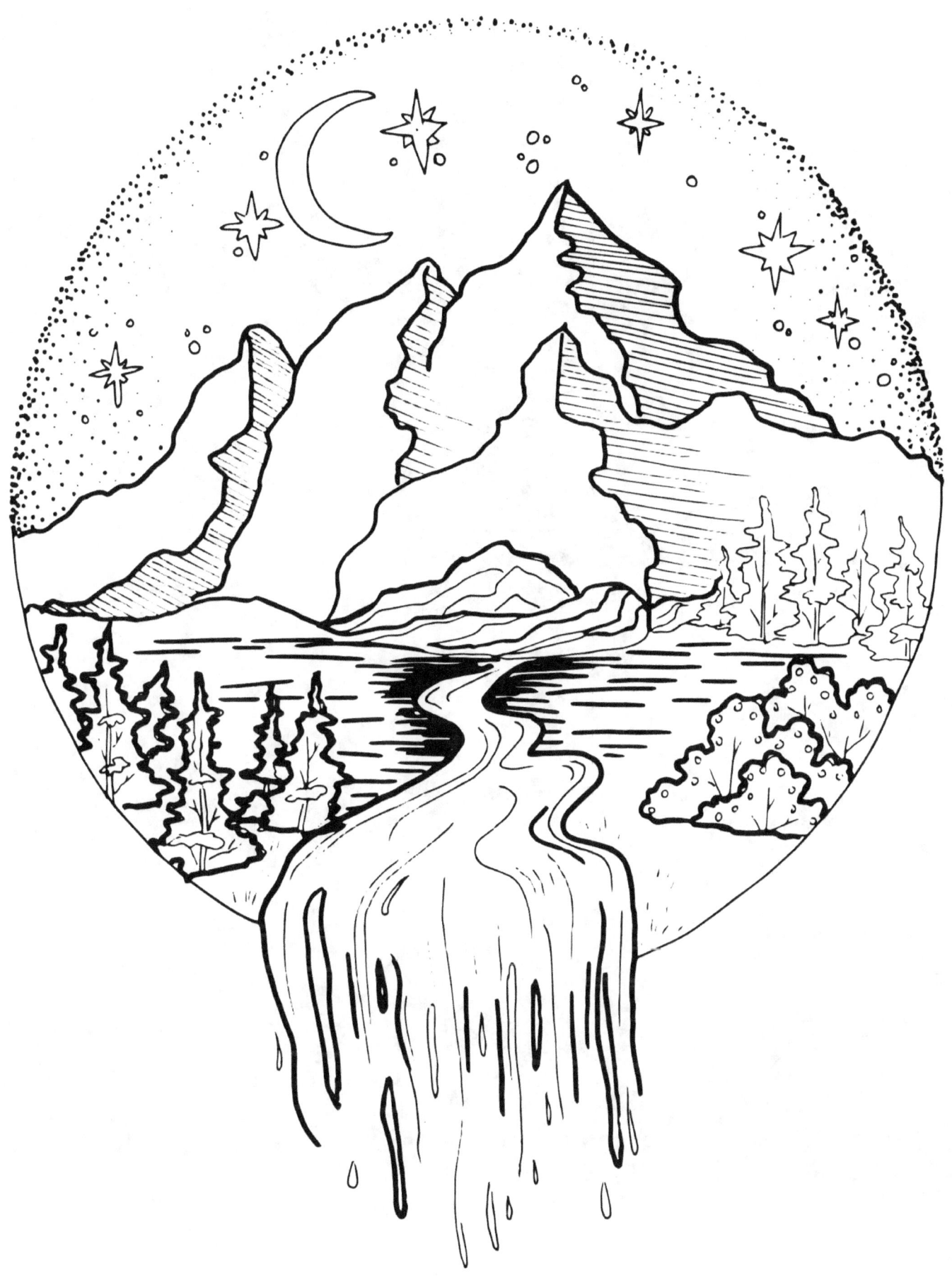

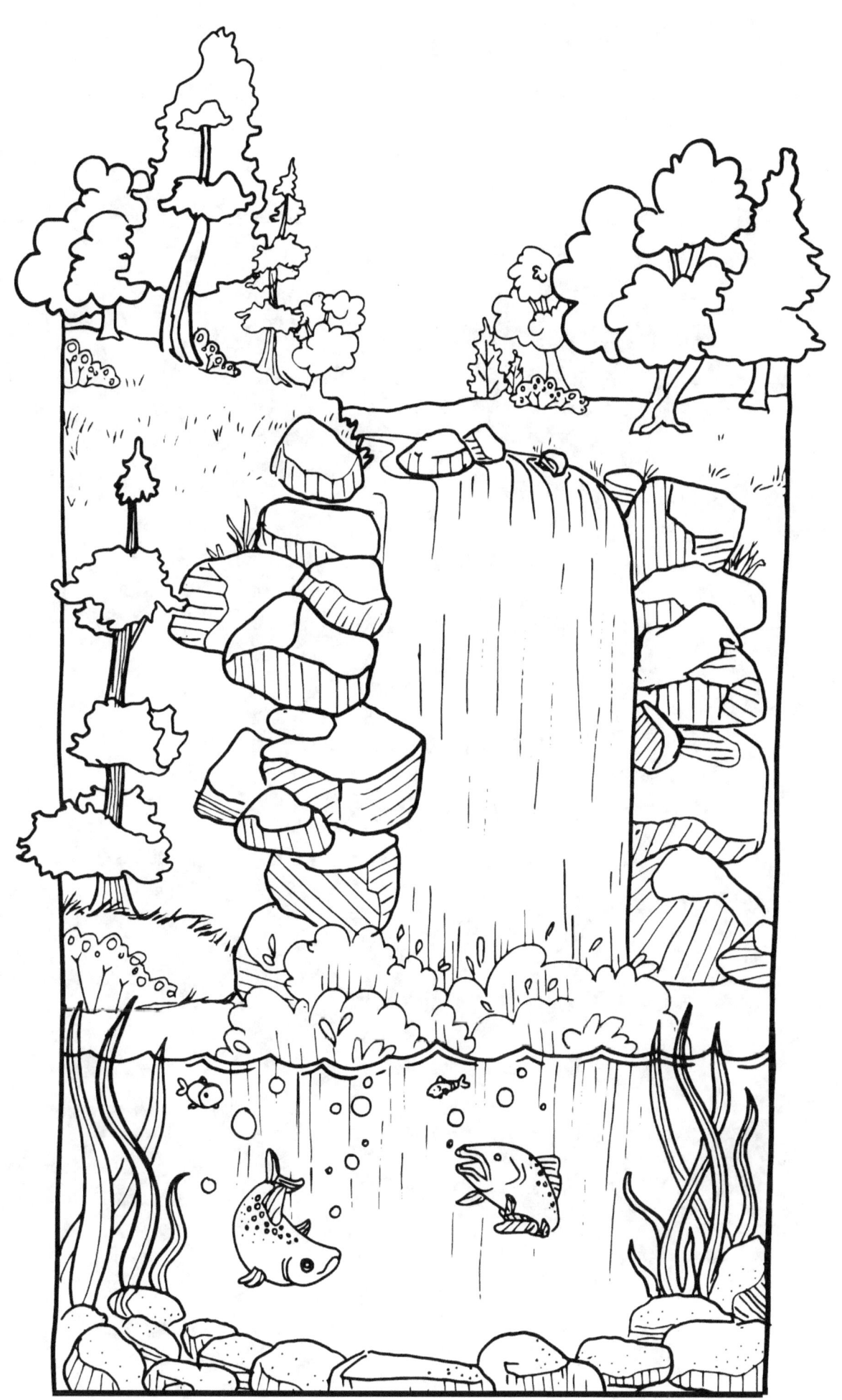

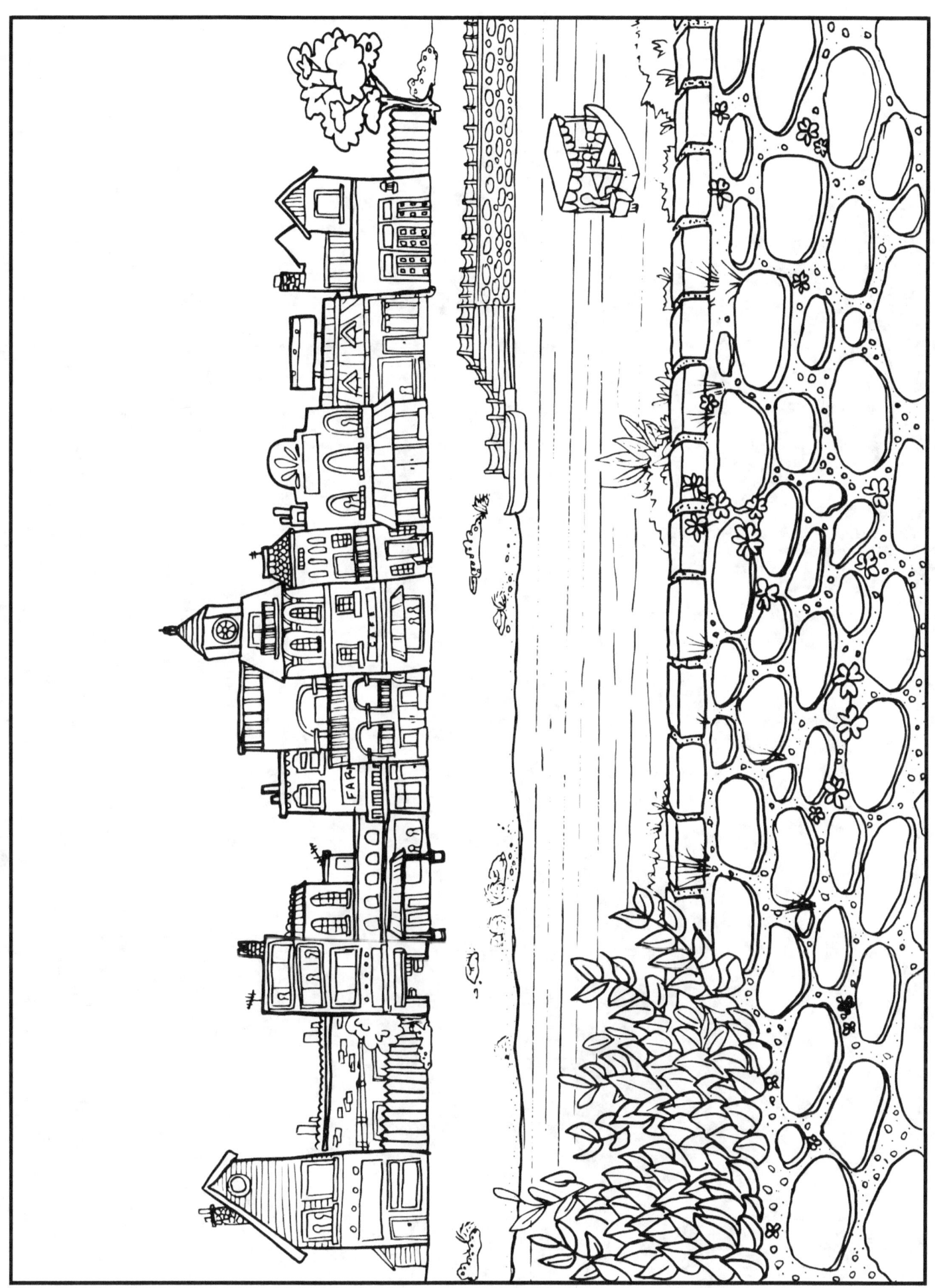

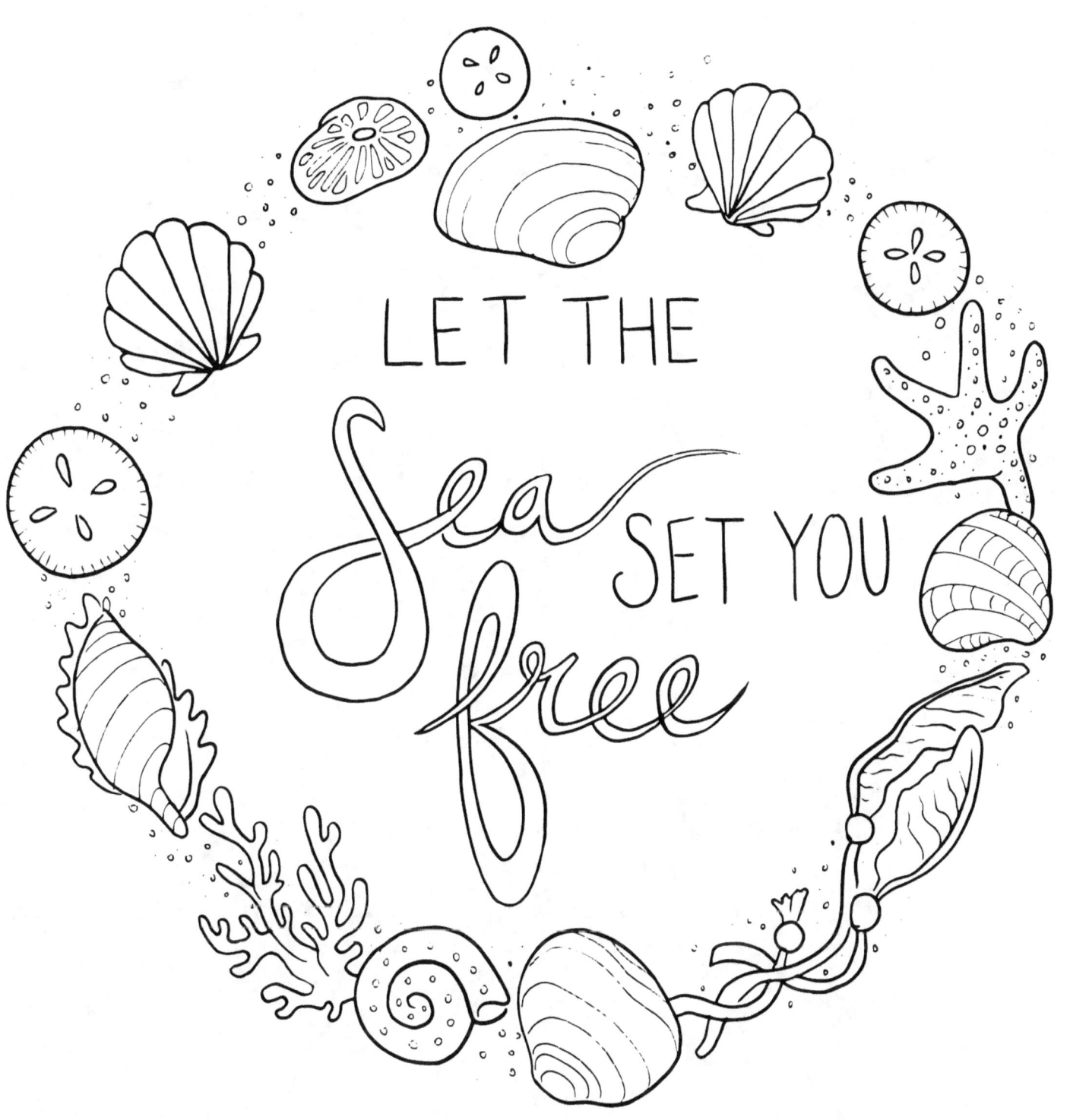

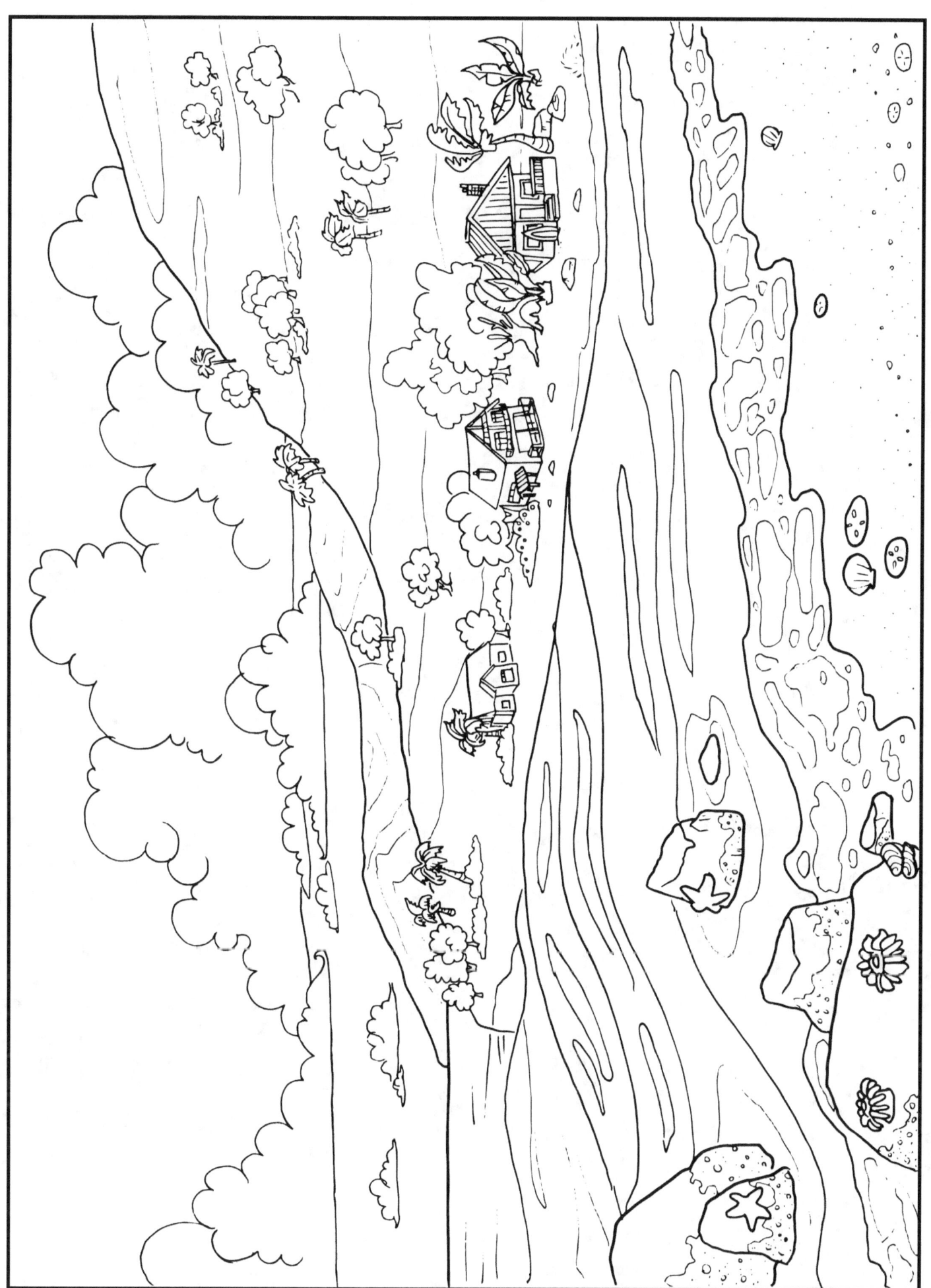

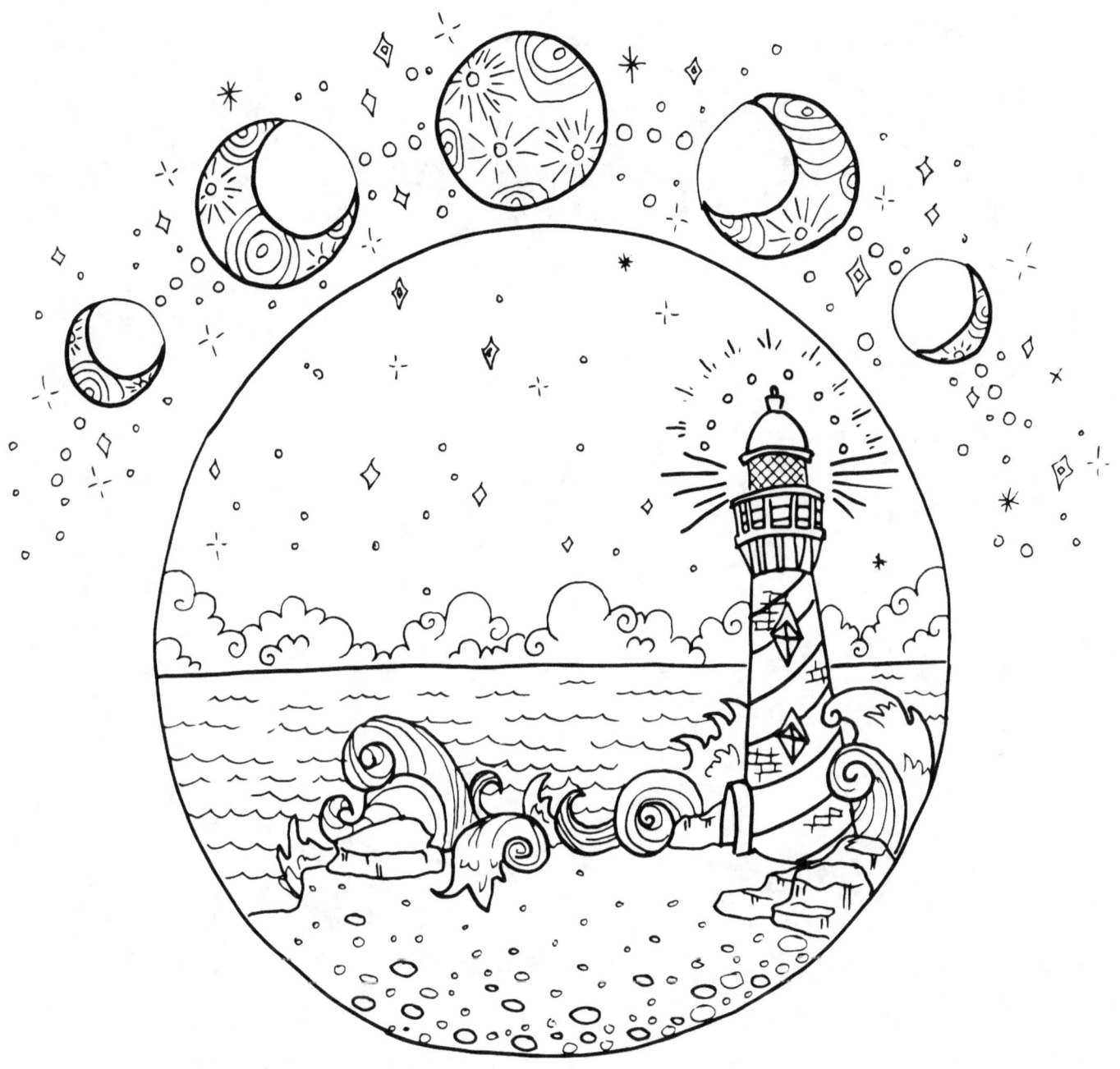

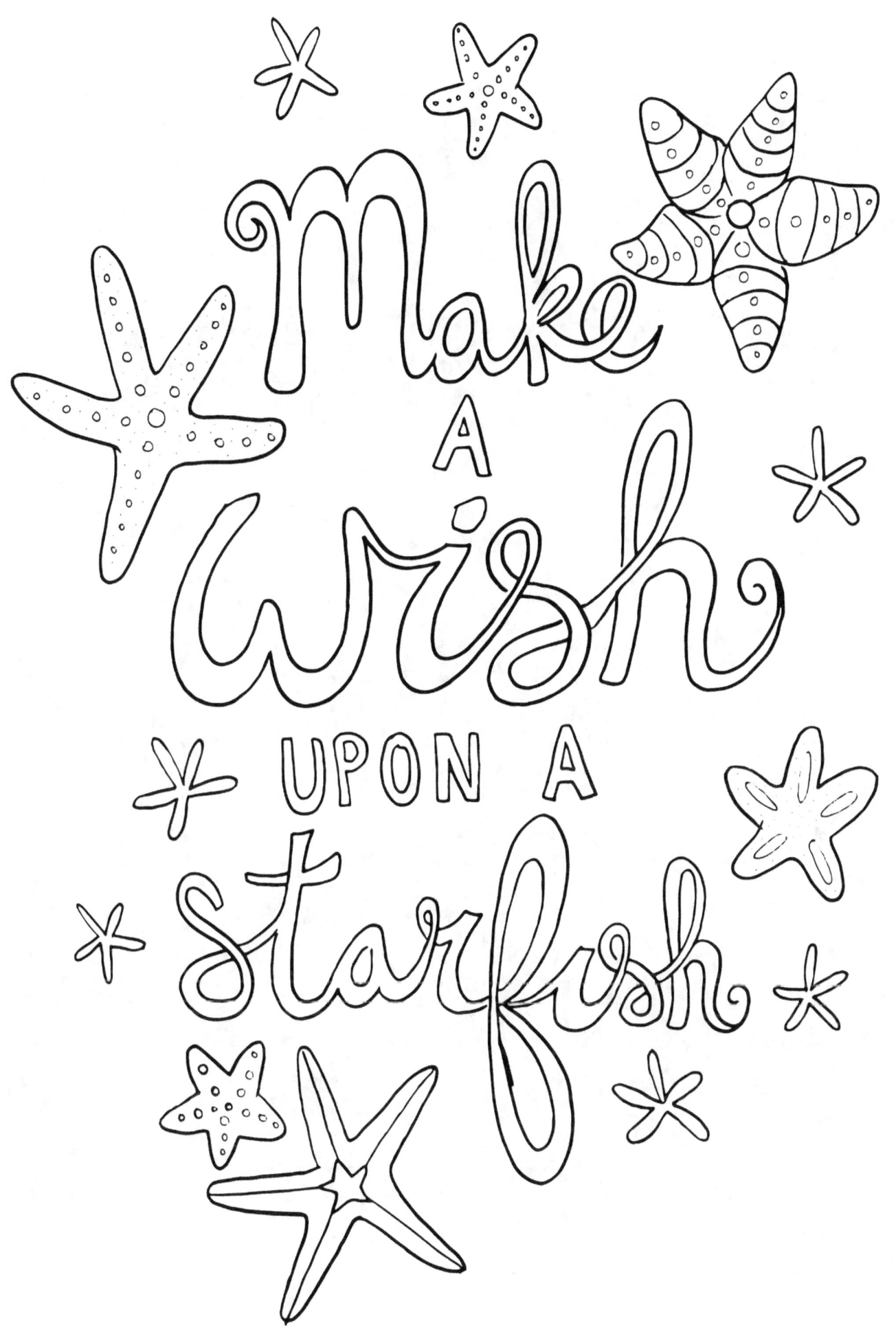

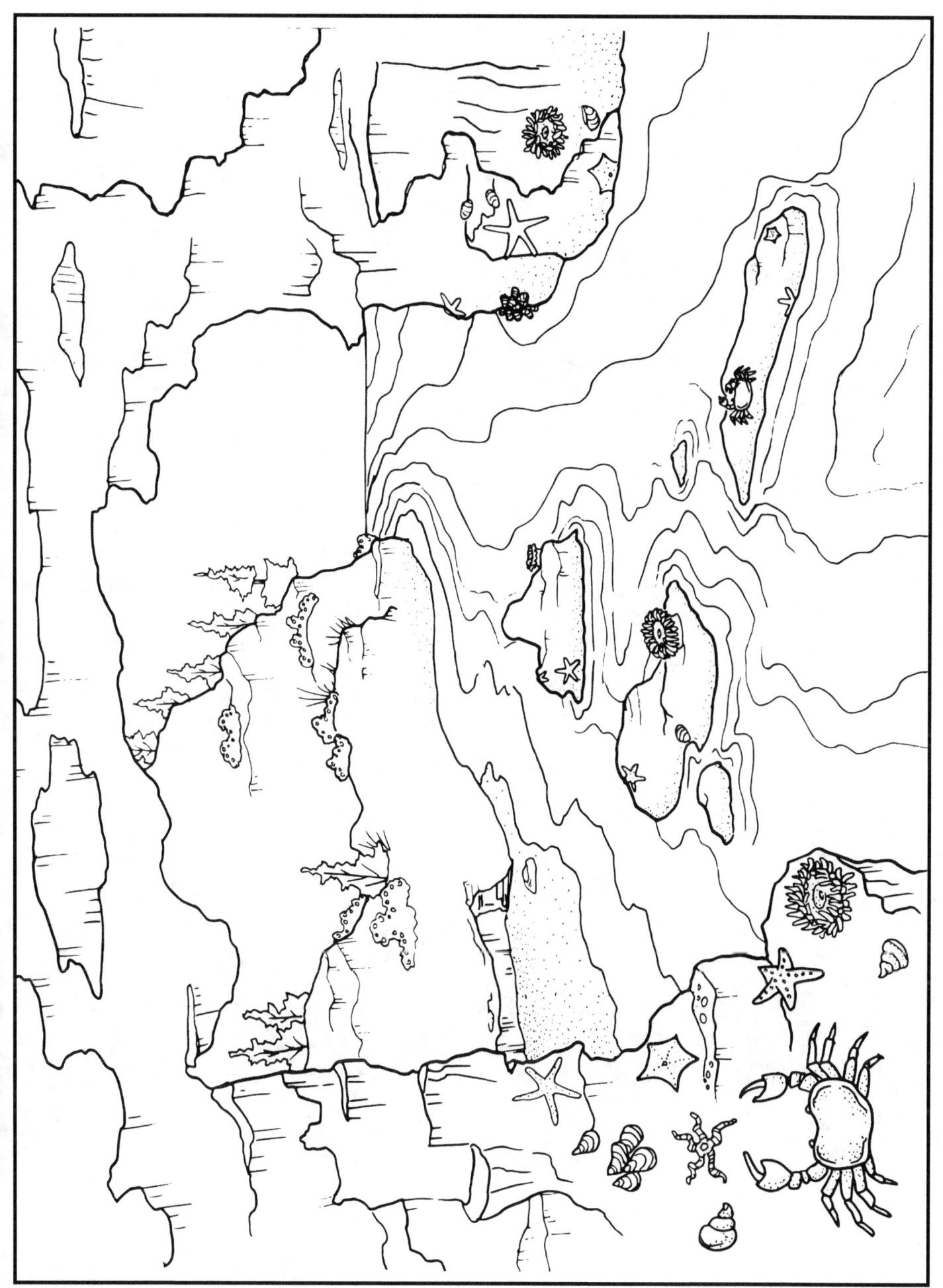

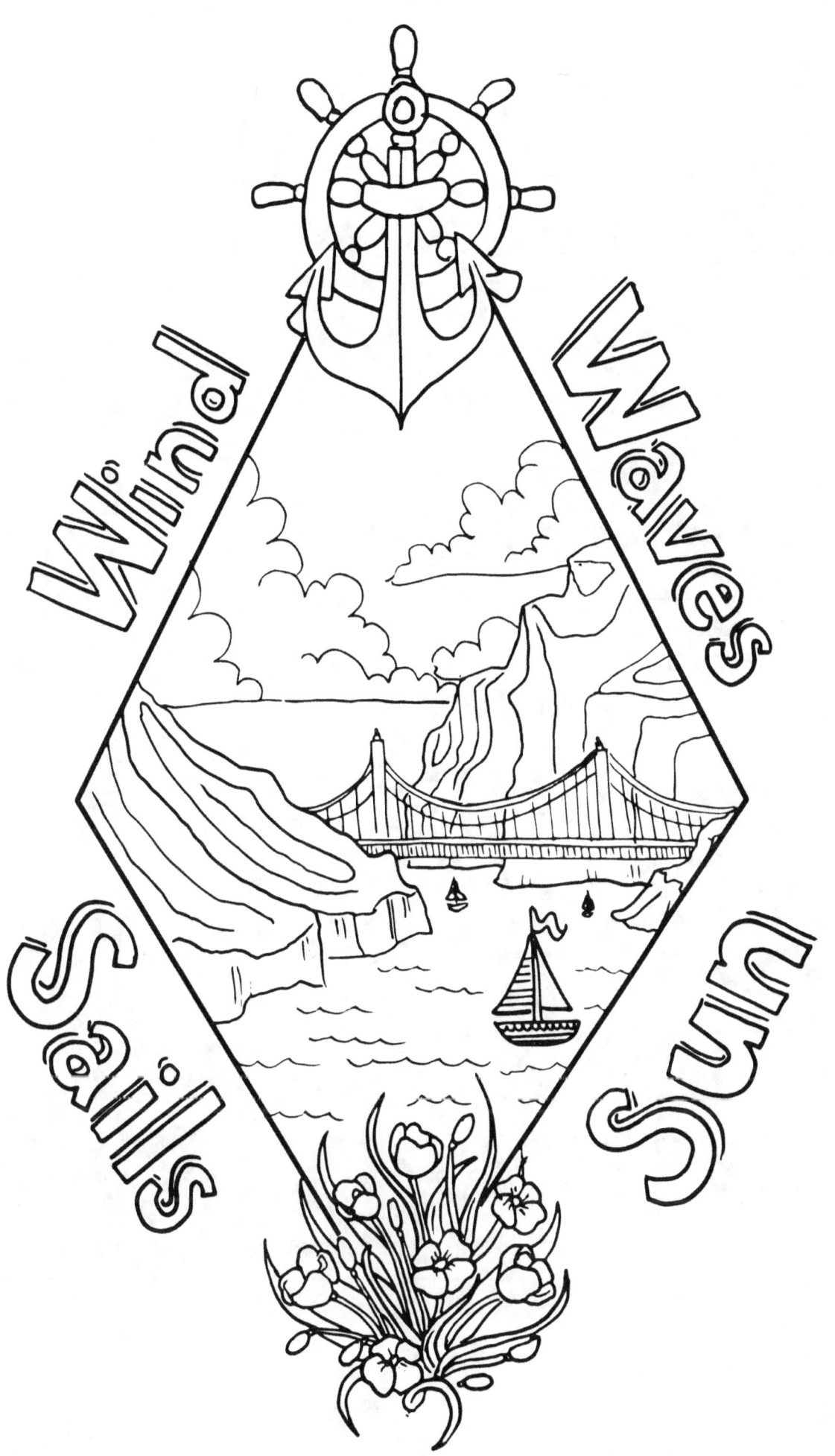

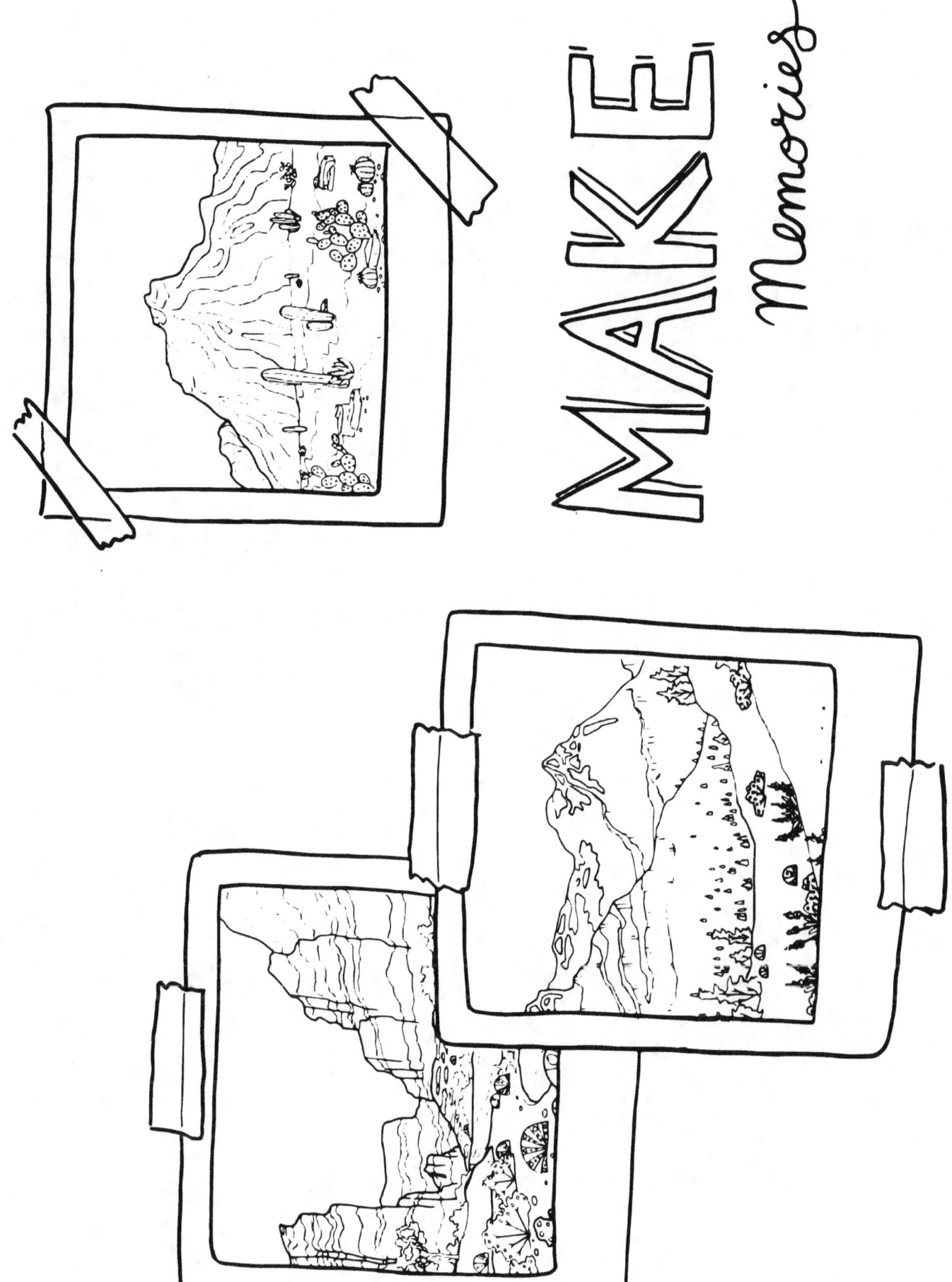

www.ingramcontent.com/pod-product-compliance
Lightning Source LLC
Chambersburg PA
CBHW081604220526
45468CB00010B/2767